Anyone *Can* Paint

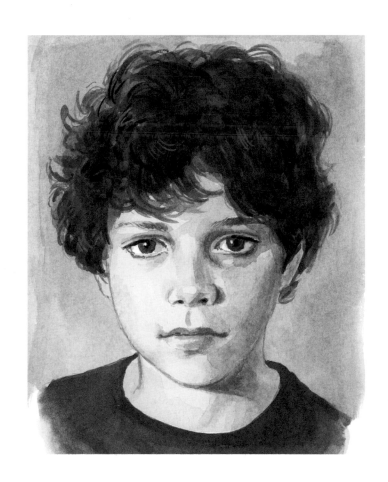

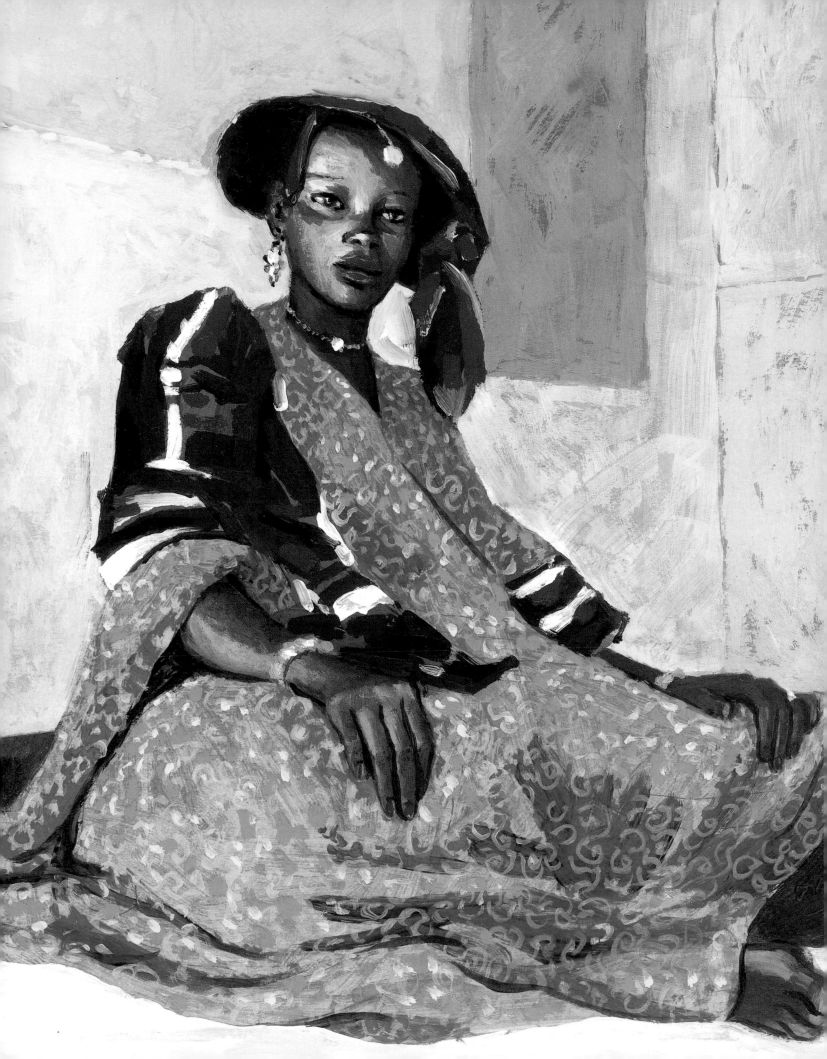

Anyone Can Paint

CREATE SENSATIONAL ART IN WATERCOLOURS, ACRYLICS AND OILS

Barrington Barber

ARCTURUS

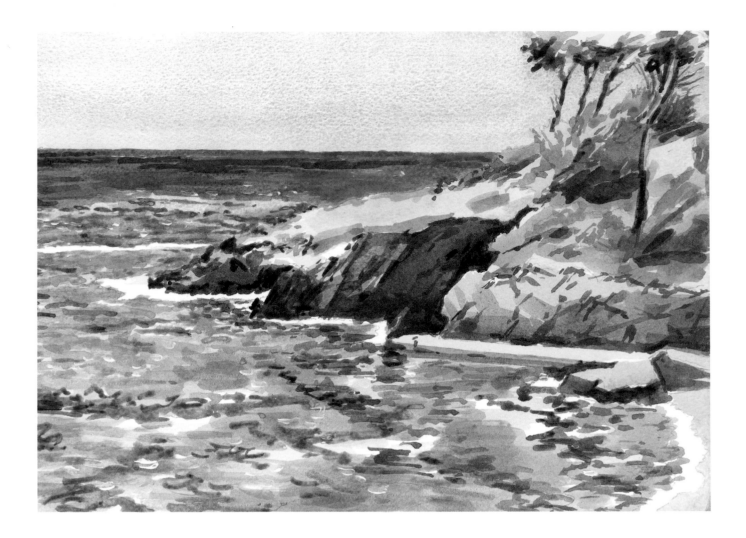

ARCTURUS

This edition published in 2016 by Arcturus Publishing Limited
26/27 Bickels Yard, 151–153 Bermondsey Street,
London SE1 3HA

Copyright © Arcturus Holdings Limited/Barrington Barber

ISBN: 978-1-78599-277-3
AD005032UK

Printed in China

Contents

Introduction

This book is about painting in watercolour, gouache, acrylic and oils, providing an easy-to-follow introduction to working in all these mediums. It suggests a range of materials to use for each, though when you start painting you will find there are many more variations available for you to explore. However, the materials described here are sufficient for producing most types of painting.

Watercolour is the first medium discussed because it is probably the most readily available and simple to handle. Gouache, also water-based, is the main type of paint used by professional illustrators, and again is quite easy to use. While acrylics are not generally the first medium for beginners, they are not difficult to work with; and although oil paint does require a bit of care, it should not be problematic once you have got the initial stages sorted out. As you become more conversant with these mediums you will find there are many different ways of using them, but this book will give you the knowledge to allow you to make a start.

The final chapter shows how to achieve good compositions, without exploring this at great length. When you start to paint you will find you want to look at other artists' work, which will also prompt ideas about how and what to paint.

Most of the pictures here are my own paintings, but some are copies I have made of other artists' works. These are mainly to convey an effect of which the particular artist was a master, so my copies are less precise than the originals.

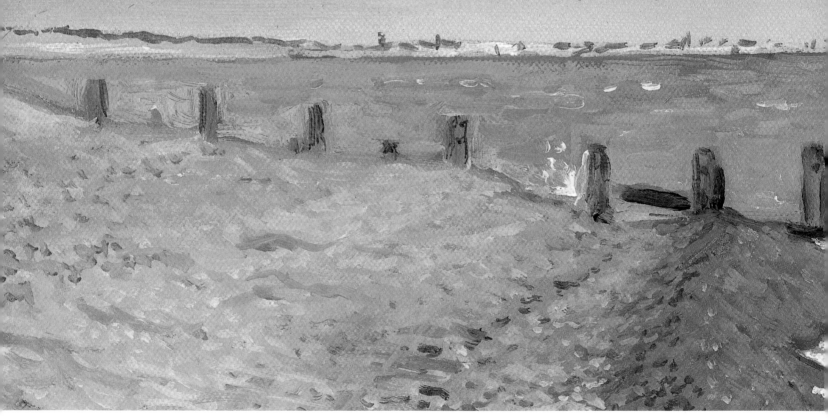

What I have found, after years of painting and teaching others to paint, is that the exercise of putting paint on paper, board or canvas is very stimulating and enjoyable, even when everything seems to go wrong. So don't be put off by early failures to achieve great works of art, because every time a painting doesn't quite succeed you will have learnt a lot that will stand you in good stead. Many of my most interesting periods of painting come when I'm not quite sure what I'm doing. This means that I really pay attention to what happens as I'm working, and that's when I learn something useful.

I believe that anyone can paint, given the desire to do so and the ability to take a bit of time to practise. The more you practise the better you will become at the particular medium, and of course you will find great pleasure in realizing what you are capable of doing. One thing you will discover is the joy of using colours to show all sorts of pictorial images that have some relevance to you and your life. When colours begin to work effectively, painting is the most satisfying activity you could imagine, both intellectually and emotionally. It is like playing some magnificent game, and you can go on playing it, developing new images and compositions without ever exhausting all the possibilities.

The world of the artist is only different from that of other people in that he or she has to look at it more closely and carefully and discover how it can be shown in pictures. While we can take photographs, there's nothing like trying to portray something with only a few drawing and painting implements. It makes you really consider what you actually see, and decide how to go about making a rendition of it that has some conviction for you and the viewer.

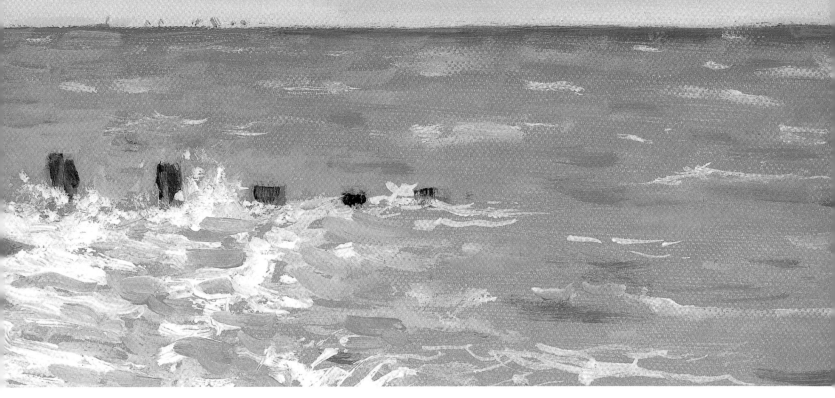

Colour theory

In order to use colours effectively in your paintings you need to understand at least the basics of colour theory. Colour is never seen in isolation, so how we perceive it is always in relation to another colour or to white or black. For the purposes of artists, colours are generally shown arranged in the form of a wheel to make it easier to see their relationships.

Primary colours

This wheel shows the three primary colours: red, blue and yellow. All other colours are made by mixing the primary colours, which cannot themselves be achieved by mixing.

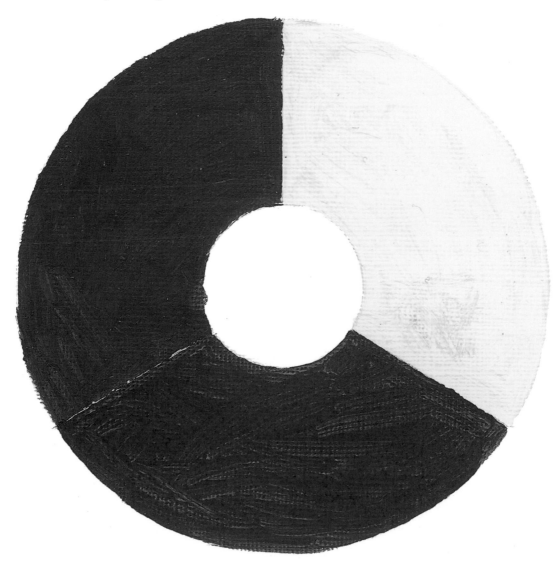

Secondary colours

The colours that result from mixing two primary colours together are called the secondary colours, and in this colour wheel they are shown between the primaries from which they are derived. So, blue mixed with red makes purple; red mixed with yellow makes orange; and yellow mixed with blue makes green.

 The colours immediately opposite each other across the wheel are called complementary colours – so you can see that the complementaries are red and green; blue and orange; and yellow and purple.

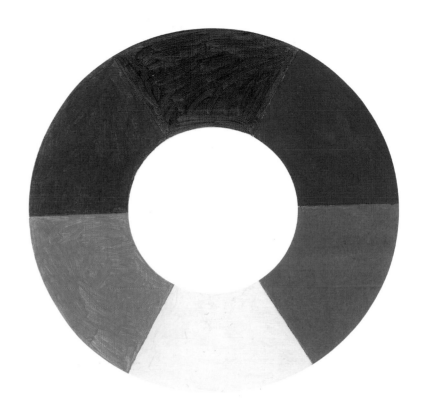

Tertiary colours

The tertiary colours are mixtures of the primary colours with the secondary colours. This extended colour wheel shows the secondary colours in between the primaries as before, plus the tertiary colours on each side of the secondaries.

 By mixing primary and secondary colours, you can make all the variations in colours you need, sometimes with the addition of white to reduce their darkness. This is how you will find all your neutral colours – greys and browns.

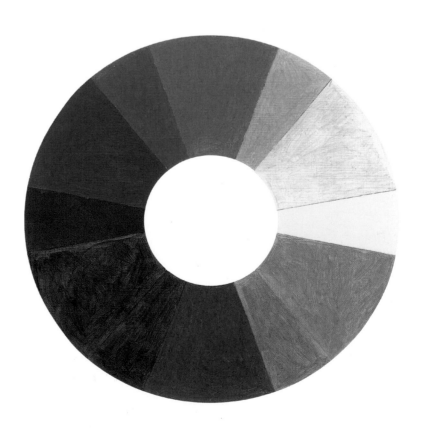

1 Watercolours

I n this chapter we shall look at watercolours. These are the most simple and ancient method of painting as they are simply pigment mixed with water in varying quantities to get the colours and tones required. Also included here are gouache paints, which are watercolours with a higher density of pigment and an added white pigment such as chalk, making them opaque. This means that you can paint over other colours easily, something that isn't possible with traditional watercolour.

Preparation and equipment

One of the advantages of watercolour is that the materials and equipment you need are very straightforward. The basics are easily found in any art supplies shop, and although you can buy various mediums to add to watercolour to give different effects, they aren't necessary to make a painting; a jar of tap water will see you through.

Choosing your watercolours

If you just want to find out whether you might enjoy painting in watercolour or not, your best plan is to buy a small box with a few colours to get you started – they won't go to waste if you want to take it more seriously. However, if you know from the outset that watercolour painting is for you, a large box of paints such as the one shown here is ideal. As you can see, it not only has the palettes in the lid, but also a second range of palettes which slot into the opposite side of the box. This is useful when you are painting for any length of time and want to mix a number of colours. The palettes clip back over the paint pans like an extra lid when the box is closed.

My favourite watercolour box is the St Petersburg White Nights set, which has 36 colours, all of them very intense. I find this quality avoids me having to pile on the paint, which in this medium is not ideal since you always need to let the white of the paper shine through the colour to give the liveliness that will enhance your work. However, most reputable manufacturers of art materials produce good standard boxes. Always go for the range described as artists' quality, since the cheaper ranges have less pigment in proportion to binders and fillers and produce an inferior result.

When you have exhausted a colour in your paintbox you can buy a replacement tablet, known as a pan, or half pan, depending on the size. All you need to do is unwrap it and slot it into place. Pans vary in price, since some pigments are more expensive than others because of the rarity of the material from which they are made.

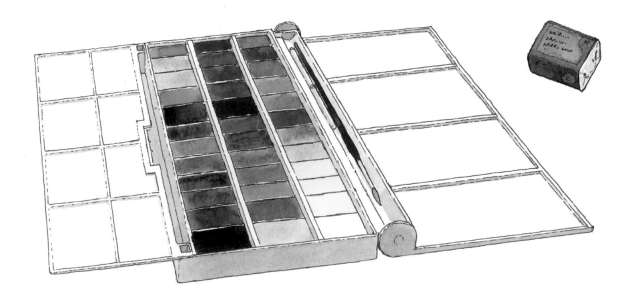

Watercolour tubes

Watercolour paints are also sold in tubes, which you may find especially useful for colours you use in large quantities. You can squeeze out the exact amount you want and dilute it. Tubes have the advantage that there's less likelihood of mixing too little for a wash, which is often the case with pans in inexperienced hands.

There are two sizes of tube – a regular one of about 8ml (0.27 US fl oz) which will be sufficient for most of your needs, and a larger tube of 21ml (0.71 US fl oz).

Gouache, also known as body colour, is a more substantial water-based paint that has greater covering power, making it useful when you want to obscure one colour with another. It can be used with traditional watercolour in various ways.

Colours

The vast amount of colours available can be confusing for a beginner. As you become more experienced you'll discover which are most suitable for your own style and subject, but to start you off here's a range of colours that will allow you to paint most subjects. It is always good to start working with a limited palette until you are more familiar with the medium.

Yellows

 Cadmium Yellow Light: *a very good basic strong yellow, which can be used widely*

 Gamboge: *a darker tone, useful for times when you require less brightness in the yellow*

 Lemon Yellow: *a slightly more acid colour that works well in combination with greens and blues*

Reds and oranges

 Cadmium Red Pale: *a strong, clear red which has an intense glow*

 Alizarin Crimson: *a rich, darker red with a bit of blue in it*

 Vermilion: *an orange-red, again quite intense, which tends to look less strident against green*

 Cadmium Orange: *a strong orange*

Colours

Blues

 Ultramarine: *a strong, intense blue which dilutes very beautifully to warm greyish tints*

 Prussian Blue: *a greenish-blue, very powerful in tone and intensity*

 Cerulean: *the lightest of this trio, very good for summery skies and warm-looking seascapes*

Browns

 Burnt Sienna: *the warmest brown, with a rich reddish colour to it*

 Burnt Umber: *a darker, slightly duller brown, very useful in mixing colours*

 Yellow Ochre: *I see this as a variation on brown rather than yellow; it is nicely rich and mixes well with other colours*

Greens

 Emerald Green: *an intense mid-green colour, which in landscapes is best diluted quite a lot*

 Sap Green: *a very useful colour for most vegetation; it's easy to vary it with colour mixing*

 Viridian: *a blue-tinted green that translates well into more distant greenery in landscape painting; it's also useful for beefing up darker tones of vegetation*

 Hooker's Green Dark: *a deep, rich green, very good for warm, strong vegetation colour*

Extra colours

 Black: *should only be used for the last marks you put in a painting, because it tends to deaden other colours. Don't mix it with other colours to make them a darker tone; use it for sharp, strong accents in a picture. Lamp Black is a good one to choose.*

 Payne's Grey: *a good colour for getting very neutral tones in a painting, but use it sparingly*

 Purple Lake: *a secondary colour, a mix of blue and red, and very useful for warm shadows. You will use it mostly in mixes with other colours rather than by itself.*

Your colour palette

There are many more colours available, but these are all you need to start with. As you become more confident you'll begin to experiment further and eventually you'll develop a colour palette that suits your needs.

Brushes

The best watercolour brushes are sable, but these are pricey. However, sable varies in quality, so you can choose according to your budget. Sable excels in holding a large amount of paint while retaining a fine point, but there are cheaper synthetic mixes you may wish to settle for at first.

You will need at least three round brushes to start with: a medium size, about number 4 or 6, which you will use quite a lot; a larger one, number 8 or 10, for laying down larger washes of paint such as backgrounds; and a smaller one, number 1 or 2, for any detailed painting you might need to do to complete your picture effectively.

You may want to buy larger or smaller brushes once you have got going on your work. Also available are folding brushes, where part of the handle becomes a lid to protect the brush when you're carrying your equipment around. You might find it useful to have a short-handled one that can fit into a paintbox.

Never leave your brushes standing in water as it always damages them. Clean them with cool water and mild soap, reshape and stand them head upwards to dry.

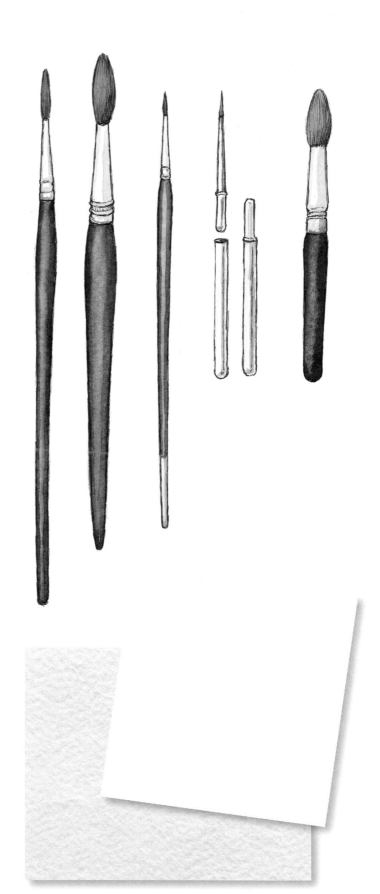

Paper

Watercolour paper is available in a range of weights and surfaces. Use a heavyweight paper such as 300gsm (140lb) or 425gsm (200lb), which won't cockle and lose its flat surface when you lay wet washes. The surfaces are Hot-pressed (HP), which is smooth; Cold-pressed (Not), which has a slight texture; and Rough. Not is the best all-rounder, while Rough is very effective for clouds and sunlit water, where using a dry brush will leave plenty of white paper showing through.

Setting up

If you're a beginner with watercolour painting you'll mostly want to paint seated at a table, though as you get more adventurous you'll be able to work almost anywhere. Find a good sturdy table on which to lay out your equipment – the last thing you want is one that wobbles just when you're making a crucial brushstroke.

A stiff piece of board to use as a drawing board is handy – plywood or MDF are good for this purpose because they won't warp or bend. To make sure your paper doesn't move or buckle when the water goes on it you can attach it to the board with masking tape, but if you want to do some very wet washes of colour, wet the paper first then tape it down with moistened gummed tape. When it is all fixed down, blot off excess water with a piece of clean cloth or paper towel, using the paper towel in a dabbing motion to avoid damaging the surface of the paper.

Have two jars of water handy, as one jar will soon get discoloured and a second gives you added time to paint before you have to change the water. If you're using a box of watercolours you will have palettes provided with the box, but if your pigment is in tubes you will need some palettes to mix on. You can buy separate palettes for watercolours, but old saucers and plates will do fine as long as they are white.

Prop up your board as shown, so that when you lay a wash the watercolour will run down the paper rather than creating pools of colour. Brush the paint across the paper horizontally in steady strokes from left to right (unless you are left-handed, in which case go from right to left). As you make each stroke, the wet paint will run into the new brushmark and gradually flow smoothly down the paper so that there's no striped effect. If the wash does have stripes, it's because your paint

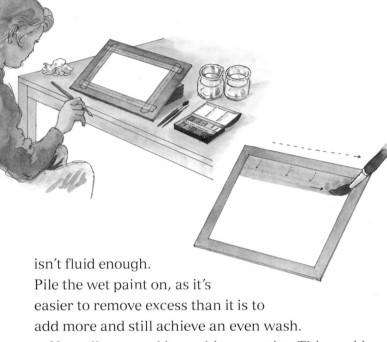

isn't fluid enough.
Pile the wet paint on, as it's easier to remove excess than it is to add more and still achieve an even wash.

Now all you need is a subject to paint. This could be a view through the window, a still life, a friend sitting as your model – anything you want.

Technical practices

Before you start painting a complete picture it's a good idea to do a little practice to fine-tune your technical efforts at using watercolour. What I suggest is that you paint a few simple designs and try a stretch of colour blending. Don't worry too much if yours aren't perfect, because as you can see (opposite), neither are mine, and I have had quite a bit of experience! In any case, with watercolour the slight mistakes or technical blips can sometimes make the picture even more attractive. These 'happy accidents' are part of the fun of watercolour painting.

First I have described a flower shape made up of three red petals and a green stalk and leaves. It's not an attempt to paint a real flower, merely a conventional shape similar to the kind we draw as children. Notice how I have left a minute thread of white paper showing between the petals so

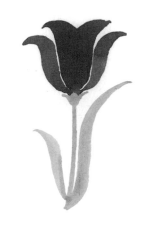

that they look separate. I did the same thing with the stalk, but a little of the green seeped into the red of the petals. However, as this looks a bit like what you sometimes see at the base of petals, it does not detract from the effect.

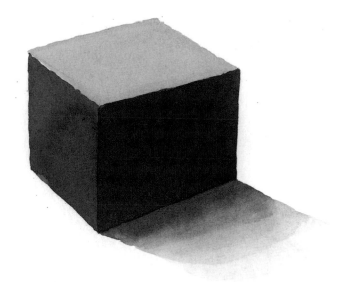

Next have a go at a vase shape. First paint an ellipse (a flattened circle) to suggest the open top of the vase and then paint a shape that is the body of the vase, again leaving a tiny sliver of white paper to differentiate the two surfaces. The eye reads this as a blue vase shape with an open top.

Next, an exercise in painting one layer of colour right up to the edge of another without the two merging wetly together. This time, after painting the top surface of what looks like a cube shape in pale red, you will have to let it dry completely before you put on the next layer of paint. You can use a hairdryer to speed things up if you are impatient, but if the watercolour paper is of good absorbency it shouldn't take long to dry. When at least the edge of the diamond-shaped top is dry, paint in the left side of the cube with a stronger, deeper shade of the red.

When that side is dry you can then paint in the second side in an even deeper red, so that it looks as if that side is in shade with light shining on the cube from the opposite side.

Finally, put in a shadow to indicate the surface that the cube is resting on. You could do this in

a purple colour, to make it clear it's a different surface. When you start painting it, dilute it more and more with water until the shadow seems to fade away into the white paper. This can be tricky and it might take you several goes before you get something that looks right.

The last part of this exercise is to paint a strip of one colour and gradually blend it into a different colour. Paint the first colour and dilute it with water until it has faded to almost nothing, then, starting from the far end, put on the second colour, again diluting it as it flows into the first colour. I have chosen a purple that is rather bluish, and blended it into a rather redder purple. It is easier to pick two colours that are not too far away from each other for your first attempts. This is tricky, and you may have to persevere before you get it right. You can see here that the paint didn't dry evenly, so there is a sort of tidemark halfway along the bluish-purple part. I've left it in, because I want you to see that your painting doesn't have to be technically perfect in order to work.

Painting simple objects

The easiest way to develop your watercolour skills further is to paint some straightforward everyday objects – preferably ones you really like the look of, so that you're not just carrying out an exercise. My examples here are three objects I found in my kitchen cupboards. If you want to choose your own subjects rather than follow my paintings, you're sure to have plenty of suitable items around your house.

I chose an orange, a cream pot and a wine glass. In each case I began by drawing the outline of the subject very simply, leaving out details but trying to get the main shape as accurately as possible. Later on you might try going straight to painting without drawing the subject first, but wait until you have gained some experience before doing this.

Orange

1 So, starting with the orange, I made a simple but careful outline of the shape and put the small stalk at the top. The shape was fairly easy to draw.

2 Next I flooded the whole shape with some Cadmium Orange taken straight from the pigment without diluting it too much – I had just enough water on the brush to make the paint fluid, while keeping as much intensity of colour as possible. Even so, the nature of watercolour is such that the first layer of colour is usually less intense than the final picture because the white of the paper still shines through until other layers are added. Use a large brush when you are laying a wash like this over large areas such as a whole fruit.

3 Next, with some very diluted Purple Lake, I put in the shadow I could see across the lower part of the fruit, and then the cast shadow on the tabletop. I waited until the first colour was almost dry before doing this – if it's just slightly damp the two colours will run into each other, which avoids a sharp edge to the shadow. I made the colour for the cast shadow increasingly diluted at the end furthest from the orange. Then I put in the stalk part at the top in a pale yellowish colour.

4 For the next stage, I flooded the whole orange shape again with the same orange colour, but this time with the board upside down, propped at an angle as before, so that the strongest part of the colour was at the top part of the orange where the paint pooled. As long as the surrounding paper is dry, the colour will remain within the shape of the orange. The hardest thing here is taking care not to brush your colour on vigorously, as that will pull up too much of the underlying colour. The pool of colour needs to be intense so that it looks like the real fruit.

5 Next I turned the board round again and painted in the most intense and dark parts, such as the shadow at the base of the orange and the shadow around the tiny stalk. The shadow needed to be strengthened all over, but each time I painted a smaller area, building a dark tone that gradually faded off towards the lighter part. With a smaller brush, I put in a little stippling (small dots of colour with the point of the brush) to give an indication of the texture of the orange skin. I strengthened the tone of the cast shadow nearest the base of the orange, washing it out towards the light area and adding a little warm brown to the purple colour.

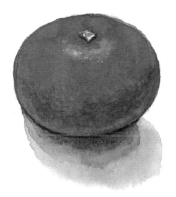

Cream pot

The same sequence of action was required with the next object, but of course the colour is much less intense. Here I used mostly Yellow Ochre, with a little purple and some brown to give more density.

1 Drawing a small pot is simple enough – just make sure that the top ellipse is drawn so that it looks convincingly rounded. Here I showed the fluting around the sides with very light lines.

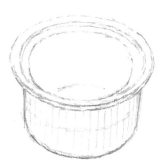

2 Then I put in a very pale version of Yellow Ochre all over the pot shape, leaving a few bits of white paper showing to indicate the highlights. When it was dry, I put in a darker version of the same colour around the sides, on the shaded part of the lip and on the inside of the pot. For the shadow, I used diluted Dioxazine Purple.

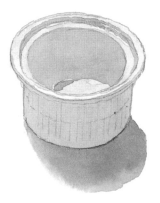

3 With the addition of some Burnt Sienna, I deepened the shadows in the pot and around the side, putting in a darker version for the fluting. When that was dry, I laid a light layer of Burnt Umber over the very lowest part of the exterior. Finally, I added a little Burnt Sienna to the shadow to give it a warmer tone.

Wine glass

The last object is probably the most difficult because of the amount of drawing you have to do with the paintbrush. The original outline is drawn in pencil, as are the other two objects, but the reflections in the side of the glass largely need to be put in by brushwork so that their edges don't look too hard and sharp. As you can see, many of them are quite light in tone.

1 Make sure that the drawing of the outline is as good as you can manage, so that the piece will be convincing. With a No. 8 brush I first put a tone over the whole outline, except for one or two places where the light shone very brightly in the reflection. These parts I left as white, untouched paper. I painted the interior part of the glass first to make sure that the shape looked correct. I made the colour inside the glass slightly stronger than the outside colour, because the thickness of the glass adds a certain amount of extra tone.

2 Then, with a No. 2 brush, I carefully put in the main darkest reflections, of which I could see two here, a grey-green around the edges and a browner tone in the more central areas. Again be careful not to go over the highlights represented by blank paper.

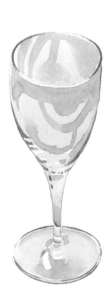

3 When that was dry, I put on the outside background colour. In this case I put the background in last because it was a discrete area and did not impinge on the rest of the painting. It also meant I could decide exactly how strong to make the colour to contrast with the colours and tones of the glass itself. I used a large brush, No. 8, which covered the area well without leaving too many marks. Doing the background first would have meant I would have had to wait for it to dry before painting in the rest of the picture. So I pitched into the main part of the picture first, knowing that the background colour would be fairly light so there would not be much problem getting the tonal values right.

Finally, in the slowest and final bit of the painting, I put in all the slight changes of colour I could see – in places colder and bluish, elsewhere warmer and browner, and with the colour of the background showing through. Be careful not to overdo it though, because watercolours that have less detail than you can see in the subject often look the most convincing.

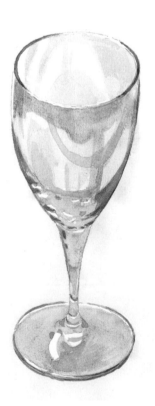

When you think your own paintings are looking like your subjects, be careful that any marks you add don't detract from the final work. With watercolour, less is often better than more because when you build colours on top of each other the effect easily becomes muddy. It's also important not to overwork the brush or you will start to get too much texture. Trying from the outset to get the colour as close to the actual colour you can see is the best way to handle watercolour, as this means there are fewer layers of paint and gives a fresher look to the picture.

Still life

Next try out a simple still life painting of several objects. Choose a combination of things you feel confident you can draw easily, or follow my painting.

1 I put together a bowl of citrus fruits, a glass tumbler, a small jug and one orange outside the bowl. Having arranged them in a group which seemed interesting enough, I started by drawing them in outline with a small brush and pale blue watercolour. It's a good idea to get used to drawing with the brush so that there are no pencil marks to show through your finished work, but if you find this too difficult, use a pencil.

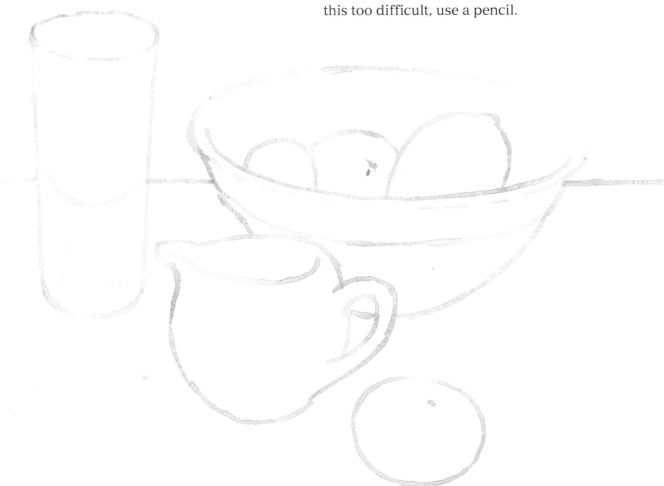

2 Next I washed colour over each area using lighter versions of the colours I could see. I put in the background wall first, with the paper upside down so that the wet paint flowed from the top edge of the table and objects to the top of the page. Then I turned the paper the right way up and put in the table colour. I left these colours to dry before I proceeded. All coloured objects will have a variety of tones of the basic colour of course, and the point here is to take the lightest ones and put them all over the areas, allowing for the bright highlights by leaving small areas of unpainted surface where the light catches it strongly.

3 When they were dry, I put in the main colour of each object, making sure that the tiny points of bright light were left as white paper. For the jug I painted the creamy colour all over first, leaving one highlight, and then when that was dry I put in the pink stripes and the shadowed opening over the top of the cream colour. With the single orange on the tabletop, I painted on the colour, then, while it was still wet, dabbed it a bit with a dry brush to pick out the lightest area.

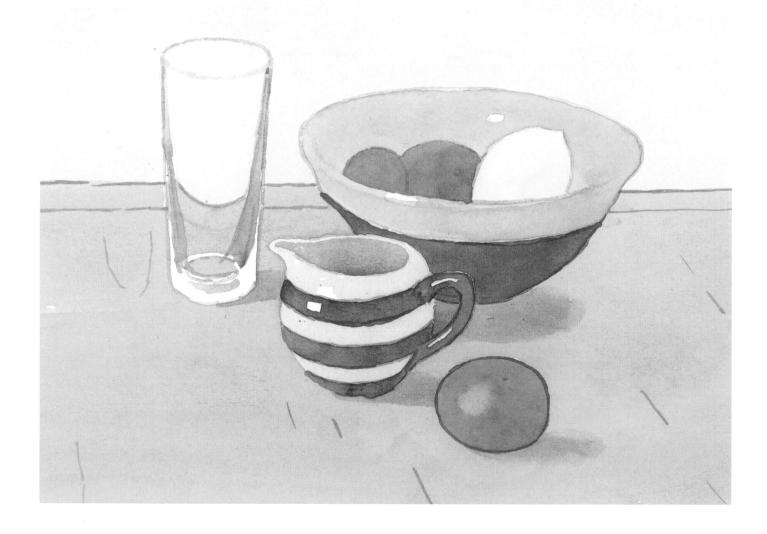

4 In the last phase, I put in stronger versions of the colour to increase the tonal values, and mixes of complementary colours to create the deeper shadows. One thing you have to be careful of at this stage is not to paint out the highlights you have left in the colour. It is quite easy to make this mistake, but if you do you can use some Chinese White (the most opaque white watercolour) or gouache white paint to put them back in again.

At this stage use your smaller brushes, especially in the tiny areas where the very darkest tones are found. I find a mix of dark blue and dark brown gives very dark tones; this enables me to avoid using black, which can easily deaden the feel of the colours.

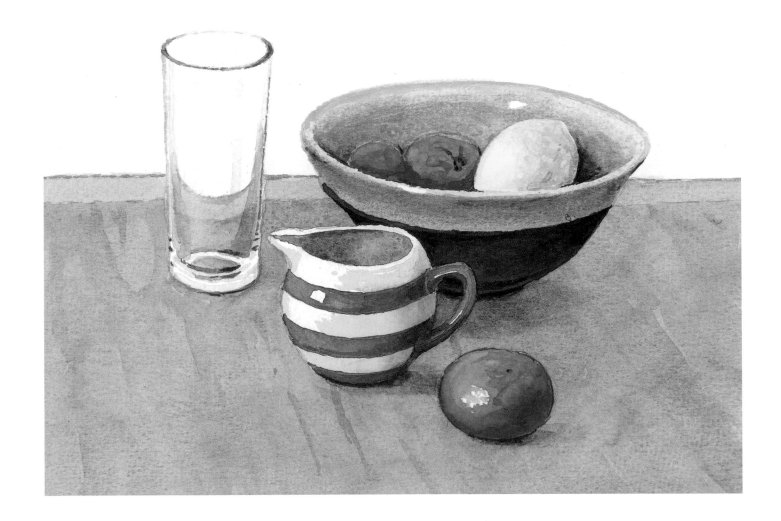

Painting flowers and plants

Before you launch into landscapes, it's a good idea to paint a few plants or flowers to get the feel of how to tackle vegetation. Focusing on a single flower is an easy way to start.

1 I took a yellow flower from an arrangement that was in the house, stuck it in a glass with water and made a study of it. First I painted the shape of the flower in bright yellow, without any detail. As it was only a small shape there was no need to draw out an edge first – I just put in the whole shape with a No. 8 brush. I then left this to dry before continuing.

Next I decided to paint in the background colour, which was a greyish-brown tone, not much darker than the bright yellow. I painted this from the bottom of the paper, raised at an angle, so that the darker tone of the wash would be at the top end

behind the yellow flower. When it was dry, I painted in a warm green stem, the centre of the flower and the darker leaves. The darker tonal values of the leaves and stalk allowed me to paint them over the fairly light colour of the background.

2 Then, with a No. 2 brush, I began to put in the stronger colours to increase the details of the petals and leaves. This process has to be done carefully, so don't rush it. You will be dealing with quite small areas, but the more accurately you put in the shapes the more convincing your flower will look.

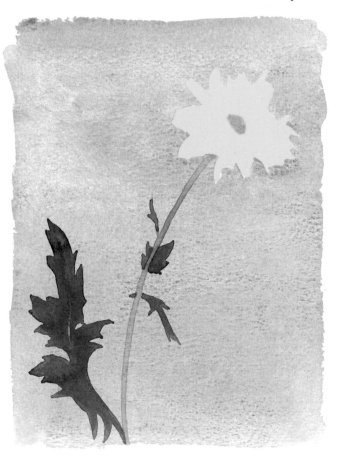

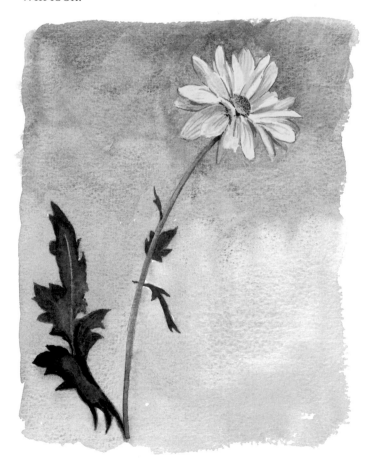

Pot of flowers

1 The next plant I painted was a potted one with bright red blooms and dark leaves. I drew out the main shapes in pencil before I started painting because my subject was rather complex and I needed some structure to work on. I kept the lines as faint as possible, but in a painting with strong colour such as this it wouldn't matter if some of them showed through the finished work.

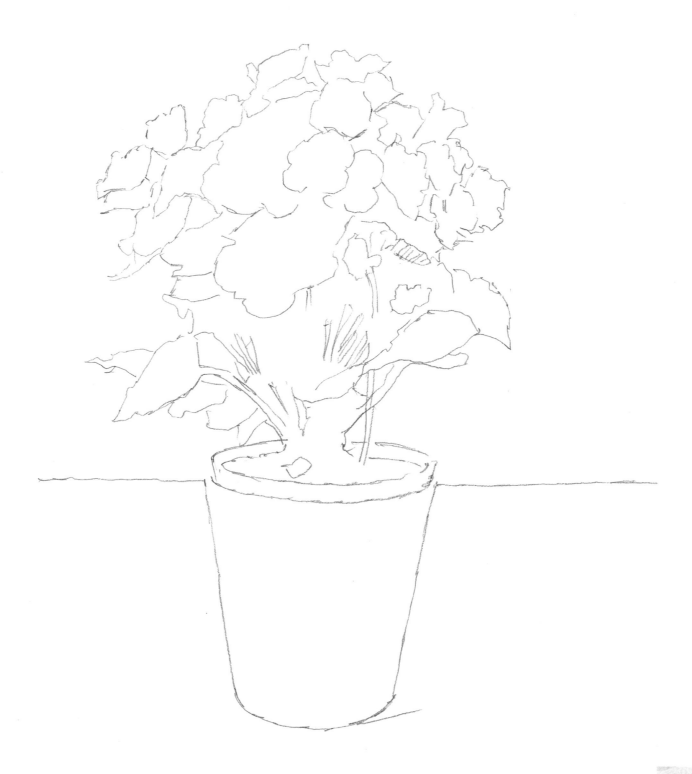

2 The first thing I painted was the background colour in its simplest form. I laid a wash of diluted Yellow Ochre with a large brush, turning the picture upside down and angling it so that the wash flowed down from the edge of the table and the plant shape, in a wet even tone, with the darkest tone at the top of the page.

When the background wall had dried, I did the same thing to the tabletop the plant pot was standing on. This time I had the painting the right way up so that the paint could run easily down to the bottom of the picture. The colour was this time a mixture of Burnt Umber, Burnt Sienna and Yellow Ochre.

Next I turned my attention to the plant itself. When all the background had dried, I painted in the bright red of the flowers, which also had some white streaks in parts. I put in the red and, before the paint had dried, washed in a bit of water to soften the edge between the lighter and the brighter parts of the flowers. So now I had flowers of mainly strong red with bits of pink and some whitish streaks among the colour. I used a strong Cadmium Red for this.

When the red had dried, I began to put in the dark green leaves and stalks using a mix of mainly Hooker's Green Dark and some Sap Green. While the colour was still wet, I traced in yellow over some of the stalk areas that appeared a less intense green than the leaves.

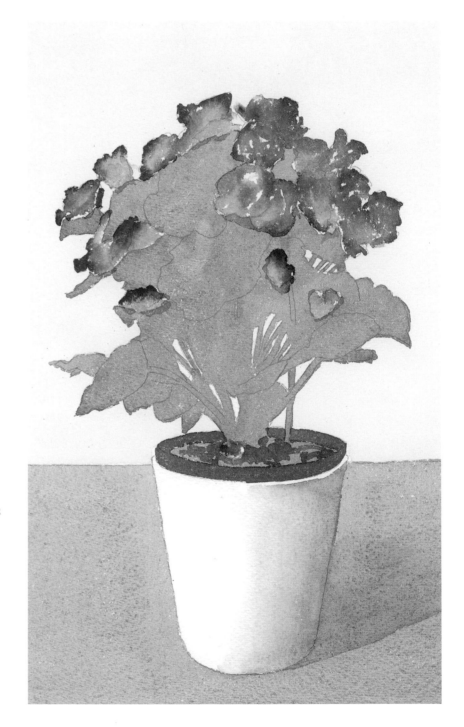

3 Now I had arrived at a point where the entire surface of the paper was covered with colour. The next stage was the slowest but most interesting step, where every part of the picture had to be defined in terms of dark and light, and sharp or blurred edges. This is where I could strengthen the red in the flowers until they stood out from the darker leaves and darken the areas of the foliage where there were deeper shadows with blue tones. I added areas of yellow over some of the leaf shapes where they looked warmer in tone, then a small amount of purple to give areas of shadow on the flowers where they obstructed the direct light. Gradually, as one paints in the smaller marks to emphasize certain parts, the picture begins to become more lively and convincing.

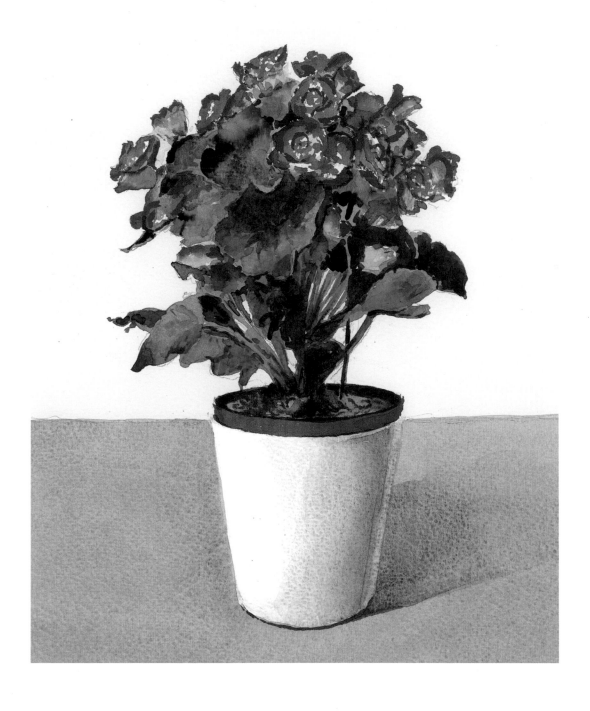

Painting landscapes

The tradition of watercolour landscapes is a long one, partly because the medium is so easy to transport and use on location. Originally, watercolours were mainly topographical pictures, often used by engineers, surveyors and the military. It was only in the 18th century that painters such as Thomas Girtin and J.M.W. Turner began to explore watercolour landscapes to the full, bringing emotion and atmosphere to their pictures. Since then, landscape has become one of the most popular genres for watercolourists, so it's natural that people who start painting in this medium want to have a go at it.

Landscapes are not easy, however. Working outdoors requires a fair bit of organization, so before you rush out to do your first landscape on location, I suggest you try painting one from a good photograph. The photographer will have already defined the scene, so all you have to do is create a painted version. You won't be able to see all the nuances of colour you would find in the landscape itself, so for your first attempt you'll be able to control your laying on of colour more easily. When you've tried that a couple of times, then by all means take to the open air and have a go at doing it from life.

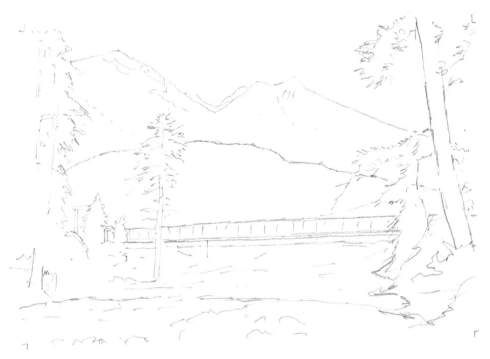

1 I selected a photograph of a mountainous landscape in northern India that I liked the look of. It had a very restricted colour range, being mostly variations of blue and green with a bit of purple. As with the other subjects we've explored, I outlined the main areas of the scene, without putting in any detail. To make things easier still, you could trace off the outlines from the photograph – don't worry that you're cheating, because all art is about cheating the eye.

2 Having drawn the minimal outline of the scene, I then laid on the sky area, holding the paper upside down so that the wet paint would run away from the horizon line towards the top of the picture. When that was dry I put in the blue-purple colour of the great mountains in the background. This time I kept the paper the right way up so that the wet paint would run away from the sky area.

The next colour to go on was the deep green of the middle ground and the trees. In both of these areas I had to be careful to leave small areas of untouched paper for the white snow. You may find it tricky at first, but you will get used to thinking ahead for your highlight areas with watercolour.

The last area was the water at the bottom of the picture, which was very streaky and also involved leaving quite a lot of white. I used two blues here, one colder and one warmer.

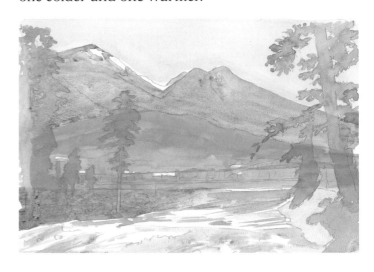

3 Having got this far, the next step was to define and strengthen the areas of colour so that they would look more convincing. I washed several layers of blue and purple over the mountain range; in the green area of the wooded hills I added warmer and colder tones of blue, green and yellow. The trees are very much darker and in some parts look almost black, similar to the bridge suspended above the torrent. To get this intense darkness I used dark brown, dark green and purple. This built a strong, almost silhouetted look to the larger trees.

The water is an area of broken colour and tone. I used two blues and some grey to give it a cold look, being careful to leave plenty of untouched paper to indicate the white foam. Before you consider your painting finished, step back from it and check if any area looks unresolved. It might just need a wash of colour or some strengthening of the darkest tones to give a final touch to the picture, but be careful not to overdo it.

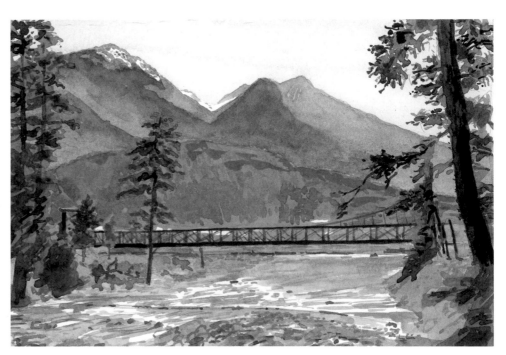

Painting portraits

While painting people is good fun it's not easy, so once again it's a good idea to practise with some colour photographs before you ask someone to sit for you. When you work with a live model you see much more to draw and paint, but a photograph is more straightforward to work from when you are starting out.

It's better if you have taken the picture yourself because you'll be familiar with the face – this will make it easier to get it right. Commercial photographs of celebrities are best avoided as the subjects are often so cosmetically altered it can be difficult to get a picture that looks real.

I took two photographs to work from, one of my grandson and the other of a female model I have painted many times. Of course I was already very familiar with their faces, and because I was using photographs, I could trace their features so that the eyes, nose and mouth were the correct shape and in the right proportion.

My grandson

1 Starting with my grandson, Maxim, I drew the outline of his face and the main features. I made sure I got his features down as accurately as possible, but left out a lot of detail because the more pencil marks that show on the paper, the less attractive the watercolour will look.

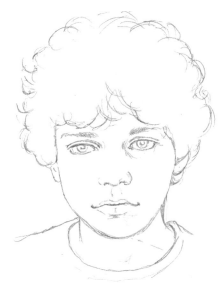

2 Next I made sure that the whole head was painted in the simplest undercolouring possible – just a wash of colour for the lightest skin tones over the face and neck, avoiding the eyes, which needed to be left white for the time being.

Then I laid a stronger wash of colour for the hair and the clothing at the base of the picture. At this point I painted over the background area with a colour and tone that resembled the background in the photo, keeping it very simple. A plain tone tends to work better than a broken background.

With a smaller brush, I put in the darker tones around the eyes, the eyebrows, the pupils of the eyes (leaving a white highlight in those) and the lips, making sure that the strongest tone was where the mouth opens. I kept the lip colour pale, to avoid it looking artificial.

At this stage I also put in the main areas of shadow, but still very lightly so that there was room to make some areas darker. When you reach this point in your own painting you will have defined the features and you will know if they look like the faces in your photographs.

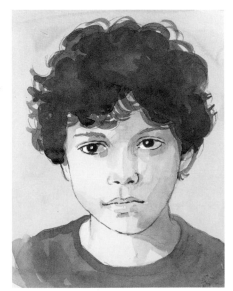

3 Now comes the fun part – though it's necessary to be very careful about every mark that's added to the picture. Build the darker tones as much as you like, but make sure the lighter areas don't get too strong, either in definition or colour. I found that at one point I had to wash a warm tone all over the face, at the risk of pulling up the colour underneath. Luckily my touch was light enough to get the tone on without damaging the lower level of colour. When you have to do this, make sure all the undercolours are quite dry or they will mix in with the top colour.

So now I had arrived at a point where the picture resembled the boy I know so well, but the colour had not become too muddy – an easy mistake to make when painting portraits in this medium.

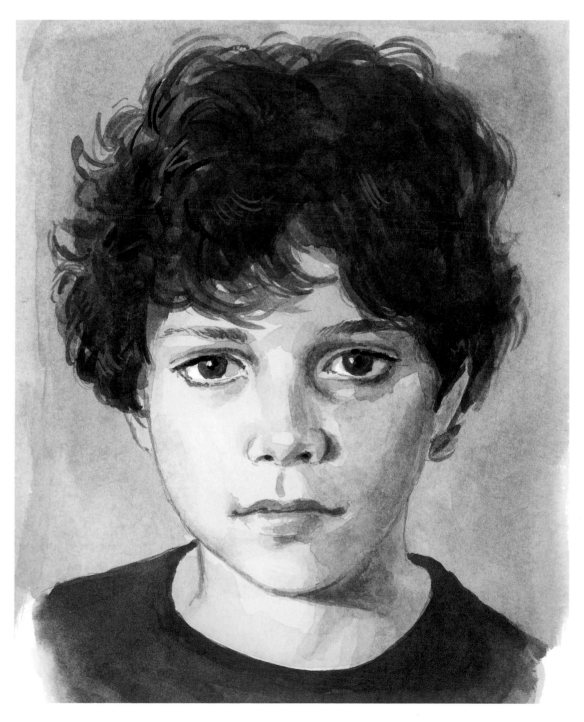

Female model

1 Once again, I started by drawing the outlines of the face and features from a photograph, keeping the lines as light as possible so they wouldn't show up in the finished painting too much.

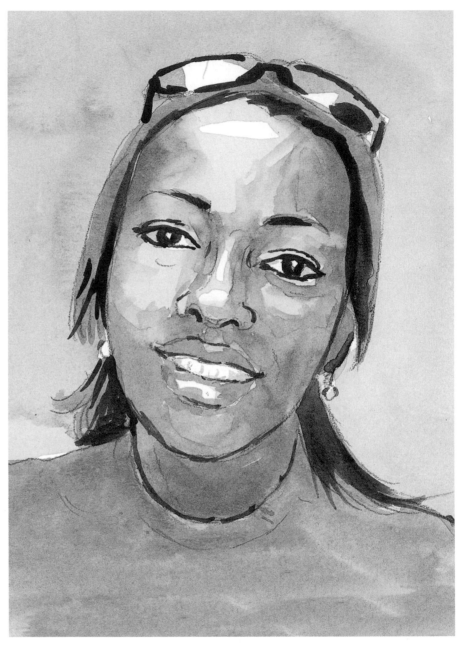

2 Next I painted in the whole head in an undercolouring as pale as the lightest tone on the face, making sure I left the eyes and teeth untouched by this colour. Then I laid a stronger wash of colour for the hair and the main colour of the clothing. I painted the background area in a single tone as close to the main colour as possible. The background in this photograph was a bit broken up and distracting, so I kept it all one colour.

With a small brush, I carefully put in the darker tones around the eyes and the pupils, leaving the highlight showing white. Then I painted the lips and eyebrows, making sure the lips weren't so bright that they looked artificial. Painting the edge of the lips too strongly does stop them from looking natural.

I put in the main areas of shadow, but lightly because there were parts that needed to look darker than the main area. At this stage you should check how your picture looks in relation to the photograph to see if it still resembles your subject.

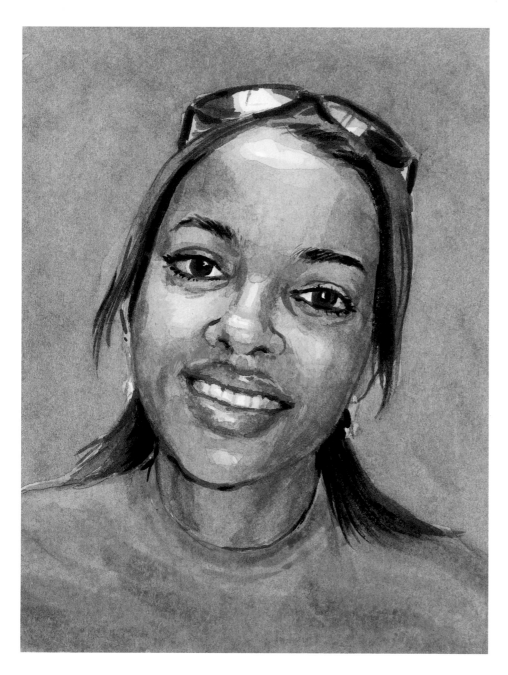

3 The last part had to be done with care and deliberation, building the darker tones. At one point I needed to make the whole face look warmer in colour, so when everything was dry I very lightly washed a tone all over the skin.

Now I had produced a good likeness of the photograph in colour, shape and tone. You may find that there are slight differences between your painting and the original photo, but this helps to prevent the result from looking too mechanical.

Now that you have attempted several different subjects in watercolour paint, you should be getting a feel for the medium and whether it is right for you. If your paintings haven't been very successful it doesn't matter too much at this stage because you will have gained valuable experience. When you first try anything, the chances of a wonderful outcome are rare and you will learn from any mistakes you make. It's always the next painting that's the most interesting and important for an artist, because everything you have done in previous paintings allows you to improve technically and perceptively in subsequent ones.

Gouache

While you can now find 'acrylic gouache' in art supplies stores, traditional gouache paint is water-based; it can be used in much the same way as watercolour, but has greater covering power. This means you can paint over colours without them showing through. You can also create extra effects with the paint and correct any parts of the work that haven't pleased you.

Colours and method

The colours of this medium are very similar to watercolour, but with added covering power. Here I have laid down three washes of primary colours: Spectrum Yellow, Scarlet Lake and Cerulean Blue.

Then, taking the same colours, but this time less diluted, I painted lines straight across the three washes. As you can see, the line colours easily cover the colours beneath.

Gouache comes in tubes and, as with watercolour, you'll need two jars for water and various things to use as palettes – I always use an old white plate or the watercolour palettes you can buy in art shops. You will need only a few watercolour brushes, but one should be fine and pointed and another should be large to carry more colour. The best brushes arc sable because they come to a beautiful point however large they are, but there are also quite good brushes made from synthetic mixes.

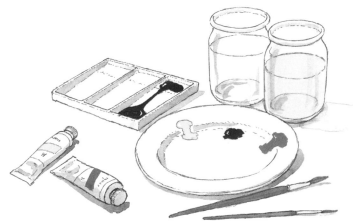

Gouache know-how

Many professional illustrators use gouache as it's suitable for small-scale painting and detailed handling. For this reason it was the chosen medium of the Mughal miniature painters of India (see page 140).

Still life

Here are some examples of still life objects painted in gouache. It lends itself to small paintings and because it is easier to control than watercolour, *especially in the later stages, you can be very precise with the work. However, it can also be used in more fluid ways.*

Bottle

1 For the first stage of the bottle, I put on the main areas of colour in a wash, as with watercolours, establishing the basic tonal value of the arrangement from the start. Gouache colours are not much different from those you find in watercolour and acrylic ranges.

2 The second stage was to strengthen the colours where they looked sharper, darker or more intense. This was mainly around the edges of the glass object. Then I put in any really bright areas with white paint, sometimes letting the undercolour show through and elsewhere blocking it out altogether. This is the great advantage of these paints over transparent watercolour.

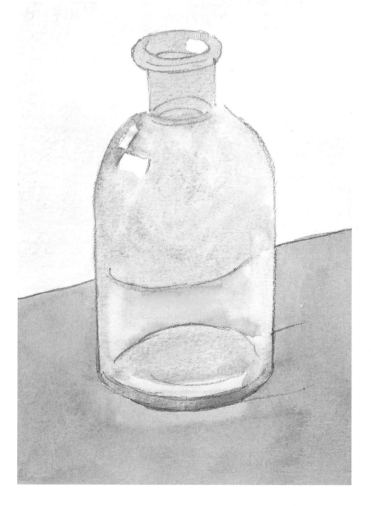
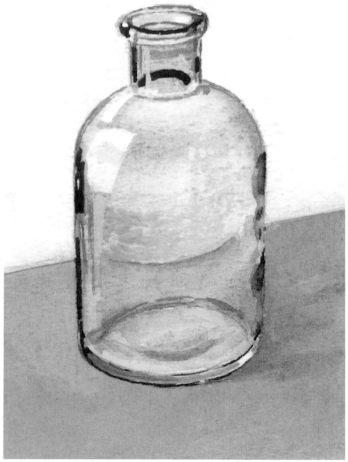

Bowl of pebbles

1 For the bowl of pebbles, I first put in the main colour of the background, bowl and each pebble, using strong or weak washes of colour as I thought best. This was a very simple exercise because the colour range is quite small.

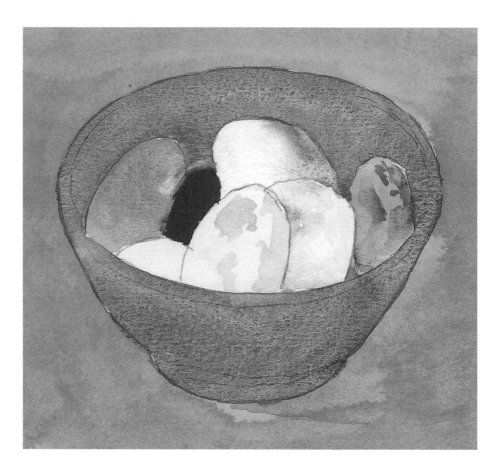

2 Next I worked up the tonal values of the stones and the bowl where the colour looked more intense and corrected the edges of the shapes to get the effect I wanted. This wasn't difficult to do, but I took my time to get the best possible result.

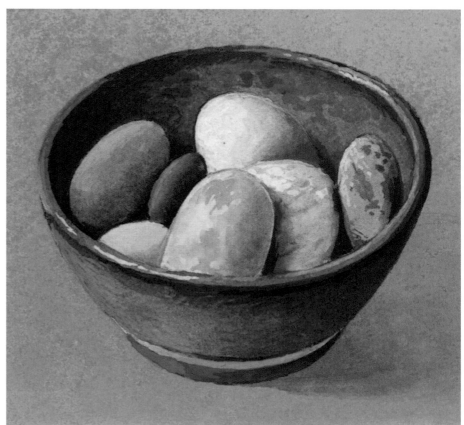

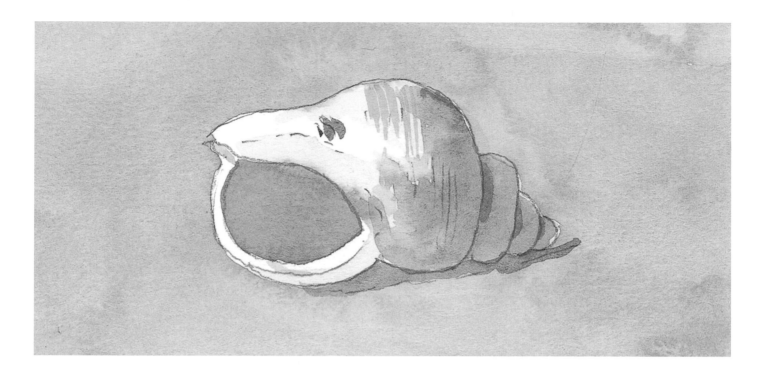

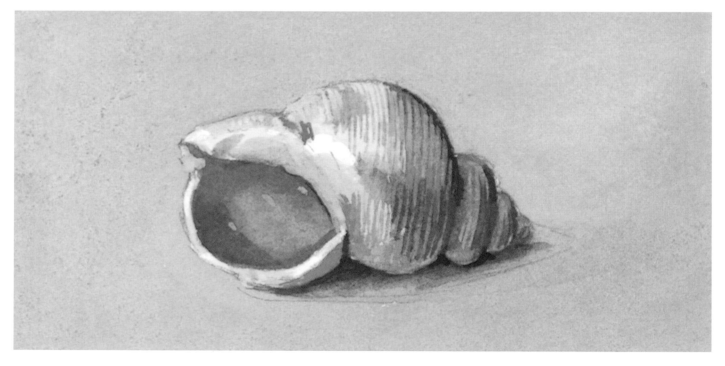

Sea shell

The sea shell was even easier – you shouldn't have too much trouble getting a reasonable version of this object. My method was the same, starting with the main areas in washes close to the final colour, then working over with stronger and more intense colour. You can simply paint over any parts you are not satisfied with.

Landscape

Here is a landscape looking over the town of Rye in Sussex on the south coast of England. The view is from the top of a church tower. There are layers of *horizontal landscape, from the horizon down to the solid gate towers that used to mark the edge of the ancient town.*

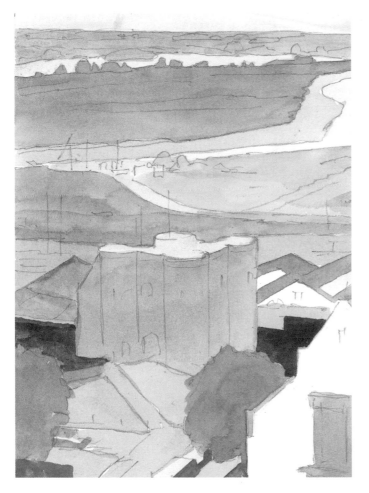

1 I started with thin layers of paint, as I would if I were painting in watercolours. I used blue-greens at the horizon, making them richer and warmer as they approached the foreground. I blocked in all the main shapes with a wash of the main colour, including the reddish-brown buildings and the greyish colour of the gate tower in the middle foreground.

2 At the second stage, I started to put in details of boats, masts, windows and so forth and the patterns of stronger greens across the vegetation, making sure that the greens in the foreground and middle ground remained richer and warmer than those in the background. The river and the lake are nice slivers of very light blue across the darker greens of the vegetation. Here's where the use of white gouache, which has great covering powers, comes in handy.

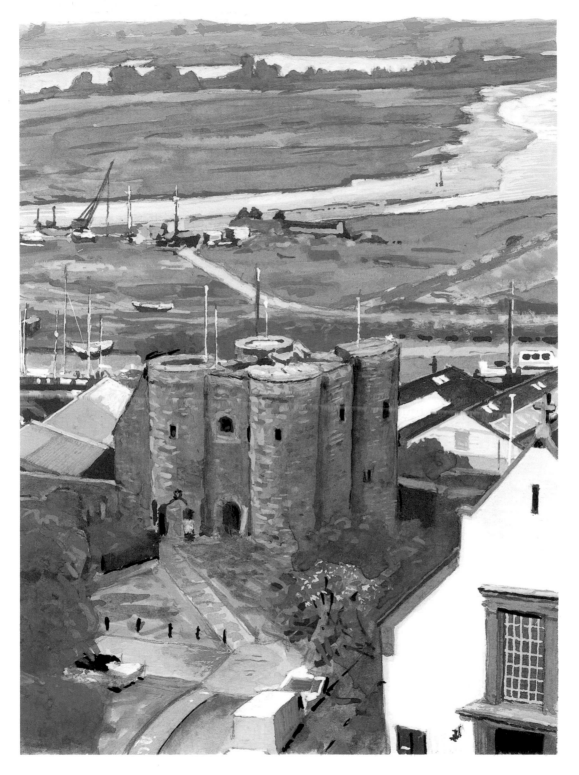

3 In the final stage, I looked very carefully at which areas were darker or lighter or cooler or warmer than others. I then worked over the top of the colours where needed, cooling them down or warming them up with thin layers of colour.

I also emphasized the most noticeable details to give some depth to the composition. Stronger shapes and colours are nearly always in the very front area of the picture.

Goose

I made this painting of a goose taking flight from a photograph, since I obviously couldn't have got a goose to keep repeating this movement while I painted it!

1 The first step was to indicate the main areas of colour as usual and put them in quite definitely, though simply.

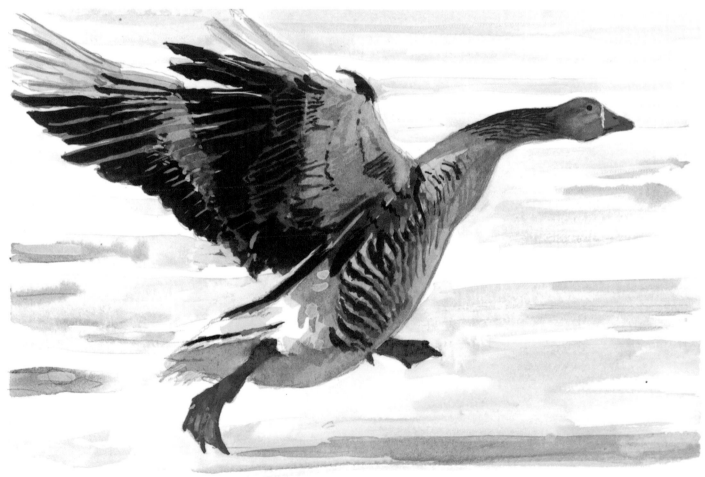

2 The next step was to increase any parts that were stronger in colour and make the patterns of feathers more distinct. As with the still life objects, this was not a tricky process because the photograph gave me all the information I needed; it was mainly a question of putting in the fine details and making sure the intensity of colour was shown correctly. The background is simple, made using very diluted paint to give the impression of water, leaving the focus on the bird.

Portrait of my grandson

I painted this portrait of my oldest grandson from a photograph, as it's not easy to get young children to pose for any length of time.

1 First I laid on the simple washes of colour to show the difference between the cool blue-grey background and the warmth of the face and shirt. I overlapped the hair, which in his case is quite dark, and the deeper shadows in the red shirt with the same blue colour of the background. The colour was laid on lightly enough for the pencil drawing of the shapes and features to show through.

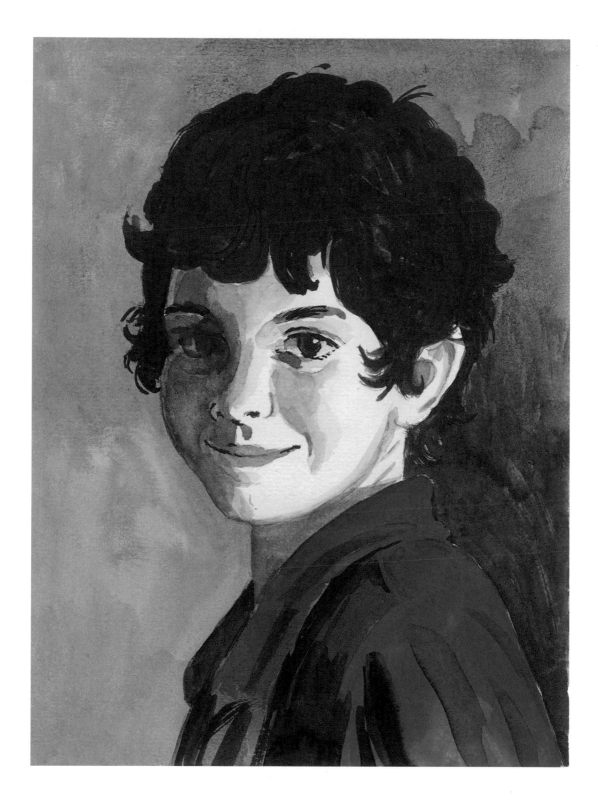

2 Next I covered the hair with a layer of rich brown and, using the same colour, put in the shape of the eyes, eyebrows, nose, mouth and some of the darker shadows. Then, with thinner layers of paint, I put in the shadows on the main part of the face and some of the reddish colour found on the lips, cheeks and ears. At this stage I strengthened the red of the shirt and put in stronger, darker tones to suggest the curls of hair, the eyelashes and the pupils of the eyes.

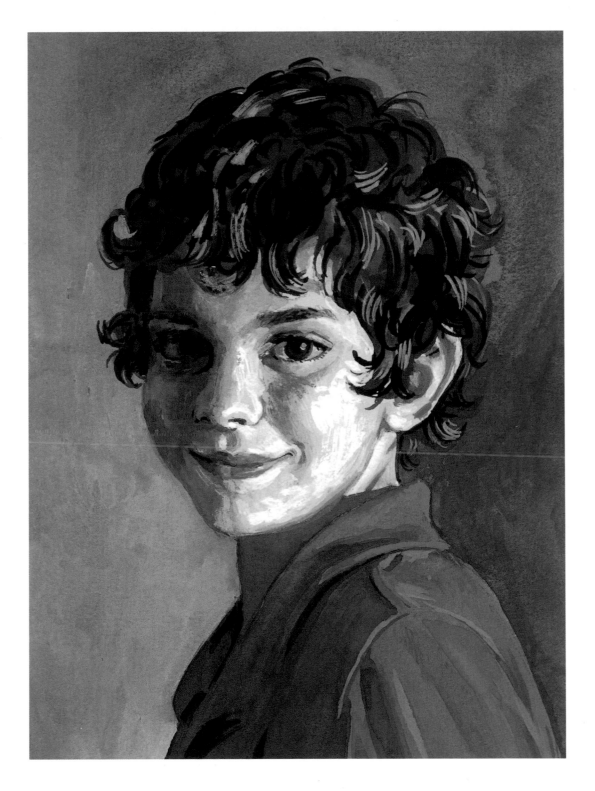

3 In the last stage I worked more slowly to correct any of the features that were not quite right, and lightened areas of the face where the light shone most strongly. This included adding little streaks in the curls of the hair, in a grey colour to make it look glossy. Lots of careful touching up of the edges of the eyes, mouth and nose were essential for the picture really to resemble the face of the sitter.

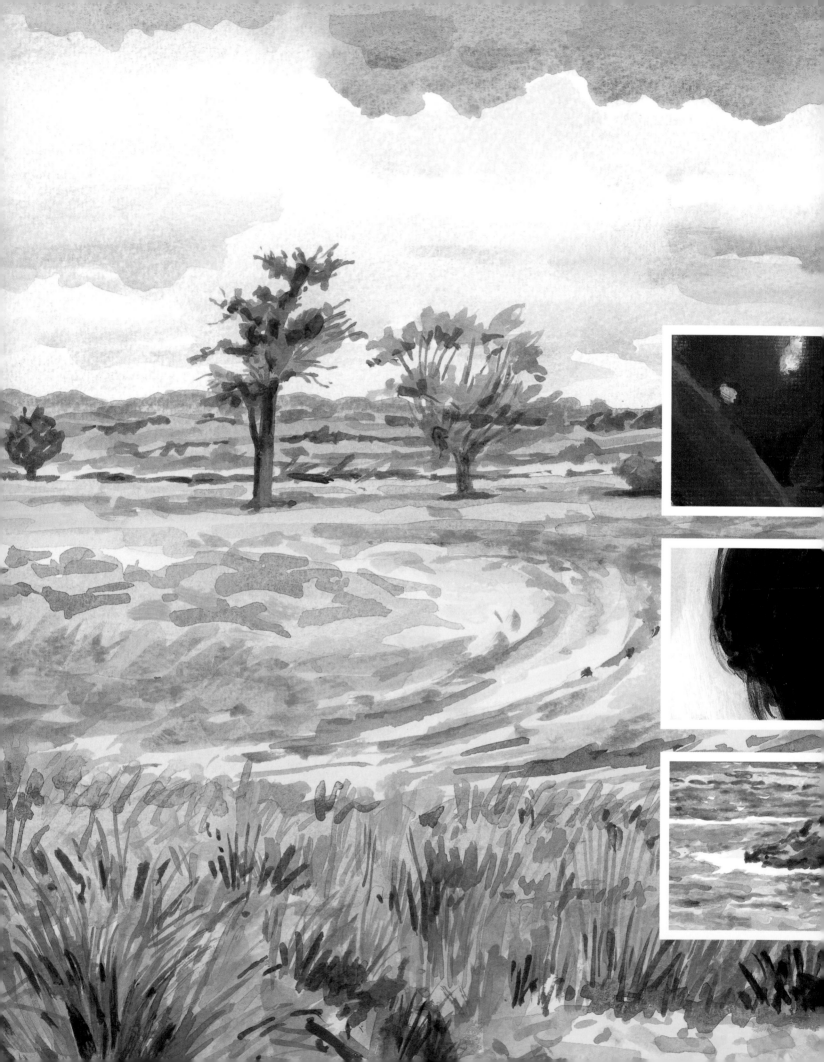

2 Acrylics

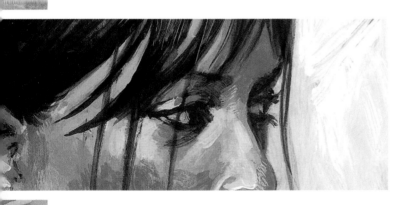

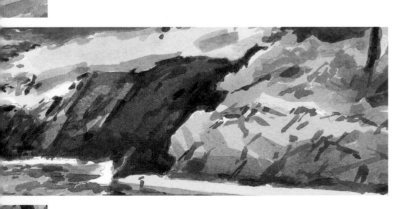

Painting with acrylics is not very different from using watercolours or oils. However, acrylics combine some of the advantages of both of those mediums: being water-based, they dry faster than oils, but like oils, when dry they are permanent. This means that once the first layer of colour is dry it cannot be lifted when you paint over the top of it, which allows you to paint many layers and add light colours over dark with as much solidity as can be achieved with oil paints.

Preparation and equipment

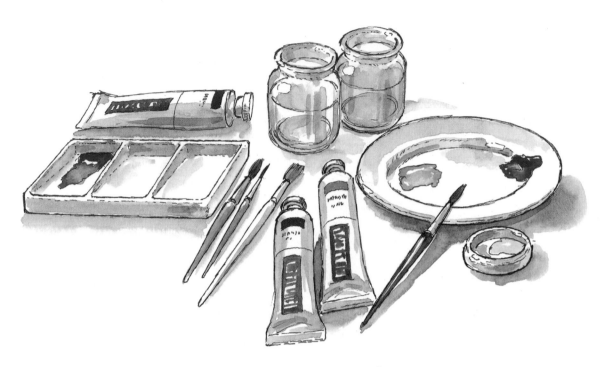

Acrylic paints come in tubes or pots and have a soft, gooey texture; they are less solid than oil paint and less fluid than watercolour. To set up, you can paint at an easel, as you might with oil paints, or work on a tabletop as is more common with watercolours. It's advisable to have two glasses of water to minimize colours tainting the brush, as you would with watercolour, and you'll need something to use as a palette. Shown above are a sloped china palette and a large white plate, both good for mixing colours. There are several tubes of acrylic paint and four brushes: one large, one small, and two medium-sized.

You can buy acrylic pads that are tougher than ordinary paper and take the colour nicely. Acrylic can be painted onto any surface, but if you use paper you will need a heavyweight type because thin paper buckles when it gets wet. A heavyweight watercolour paper of about 300gsm (140lb) is just as good as paper intended for acrylics.

Colours

Many acrylic paints are named after the materials they are derived from, which means the colour names are slightly different from those of watercolours or oils. Generically speaking, the difference in names is not too important and you will soon get used to it. The following colours are a good selection for you to start with:

- *Zinc White, Titanium White*
- *Carbon Black*
- *C.P. Cadmium Yellow Light, Yellow Ochre*
- *C.P. Cadmium Orange, C.P. Cadmium Red Dark, Quinacridone Red Light, Vermilion*
- *Light Green (Yellow Shade), Hooker's Green Hue, Cobalt Teal, Permanent Green Light, Viridian Green Hue*
- *Burnt Umber Light, Burnt Sienna*
- *Dioxazine Purple, Light Violet, Manganese Blue Hue, Ultramarine Blue, Cerulean Blue Chromium*

Exercises with acrylics

To give you an idea of how acrylics work, try out this little exercise in laying on colour. This medium can be painted on in a thin wash of colour or laid on fairly thickly. As it is water-based, it dries quite quickly.

1 First, paint a smooth horizontal strip of one colour, keeping it as a thin layer of paint. I used Yellow Ochre for this.

When it is dry, paint a series of strips of thinly diluted different colours vertically over the first colour, so that the top half of the vertical strips is on the white paper.

As you can see in my example, the colour of the ochre shows through the second layers of colours and changes them to a certain extent. It's rather like painting a thin glaze in oil paint. The other colours I used here are C.P. Cadmium Yellow Light, Ultramarine Blue, Quinacridone Red Light, Vermilion and Permanent Green Light.

2 Next I used Quinacridone Red Light for the horizontal strip, and when it was dry painted thinly across it in a similar way to the previous

exercise, but with spaces between the colours. I used C.P. Cadmium Yellow Light, Ultramarine Blue, Permanent Green Light, Yellow Ochre, Vermilion and Hooker's Green Hue. So you can see how the colours affect one another when painted as though they were watercolours, with a thin layer rather than a thick one, and how different they look when they have white around them.

3 In this next exercise, I laid the first colour on thickly, at its most intense hue. Then when it had dried, which took a bit longer because of the thickness of the paint, I painted two swatches of different colours to overlap the edge of it, laying the paint on thickly so that the top swatches completely blotted out the colour underneath.

I tried this exercise with three strong undercolours of Cerulean Blue, Cadmium Red Dark and Permanent Green Light. The overlaying swatches on the blue base are Yellow Ochre and Vermilion; on the red base I used C.P. Cadmium Yellow Light and Cerulean Blue; and on the green base I painted Vermilion and C.P. Cadmium Yellow Light.

If you want the colour to be even more opaque, add Titanium White to strengthen its covering power – but remember that this will lighten the original colour as well.

Painting simple objects

Apple

1 To start with, here are simple steps to show how to paint an apple in acrylic colour. First, I drew the main shape in pencil, then used an undercolour wash of C.P. Cadmium Yellow Light all over the area of the apple. The cast shadow is painted in with Light Violet. To keep the picture simple, this is the only area of background shown.

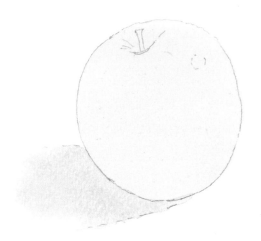

2 I painted the main area of red with Quinacridone Red Light, adding some stronger lines in the same colour to show texture. I used a little light wash of Burnt Umber Light for the shadow of the stalk, the stalk itself and the depression that it grows out of, and put in a touch of Titanium White to mark the highlight on the upper curve of the apple. I also added a little touch of Ultramarine Blue and Burnt Umber Light to darken the cast shadow where it is nearest to the edge of the apple.

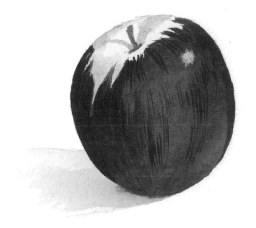

3 Next I carefully put in some shading with a light wash of Burnt Sienna and a touch of Permanent Green Light. I put streaks of Yellow Ochre over this to show the lighter colours breaking into the red, then added some darker marks in C.P. Cadmium Red Dark to emphasize the striations of colour on the surface of the apple. All these streaks of additional colour needed to follow the curve of the apple to help define it. I added a little more white in the highlight and another darker layer of tone on the stalk and its shadow. Then, to finish, I lightened and darkened the cast shadow in some parts, using C.P. Cadmium Yellow Light and Dioxazine Purple.

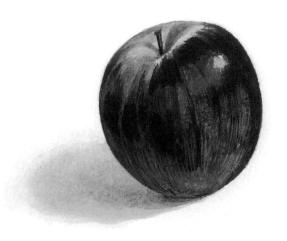

Rose

1 This red rose is another simple object, but more delicate and complex in form than the apple. Having drawn the outline in pencil, I painted a wash of C.P. Cadmium Yellow Light over the background area and then a wash of pale Quinacridone Red Light over the area of the petals. The stalk and leaves are in a pale version of Permanent Green Light, with the yellow beneath showing through.

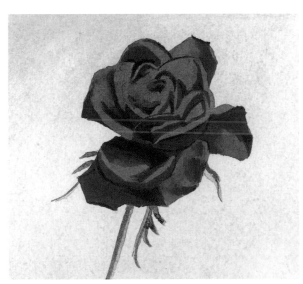

2 In the next stage, I darkened the background with a wash of very pale Yellow Ochre, then defined the form of the flower and leaves with some C.P. Cadmium Red Dark. Then I added another layer of a mid-tone Quinacridone Red Light to show the brighter parts of the flower.

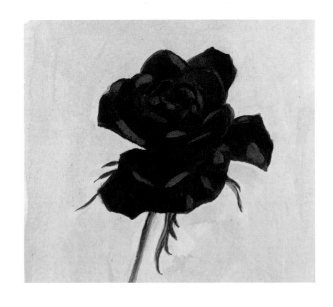

3 Next I put in the very darkest tones of the shadows between the petals of the rose with Dioxazine Purple and Burnt Umber Light, then washed in some layers of the brightest Cadmium Red over the areas which look most strongly coloured. With some touches of Umber and Hooker's Green Hue, I darkened the leaves and stalk and made them more substantial. After a last look, I decided some lighter touches were needed on the lightest parts of the flower; I put these in with a thin layer of Titanium White.

A simple still life

In this very simple still life arrangement, you will see the stages of producing an acrylic painting which has the qualities of both a watercolour and an oil work. With acrylic, you can lay out thin washes of colour with a large, soft brush and get translucent areas of pure colour, then add thick layers of paint, as with oils. Of course, it's possible to just paint the whole picture thickly if you are confident enough to get the marks right from the very first steps, but in these examples I have taken the approach of starting with thin layers and building up to thicker layers.

My first example is a bowl of tomatoes and red peppers I had in the kitchen in readiness for a meal. It looked so attractive, I decided to use it for a composition. I didn't try to set the bowl in a particular space, but decided on a bird's eye view of it with not much of the background showing. This simplified the composition, and although I could have rearranged the objects in the bowl, I chose to go with what was already there.

Hue, thinly enough to let the white paper soften the darkness of the colour.

The bowl was pale yellow with a darker green on the outside; I could just see a strip of green round the edge. Because of the shadows cast, neither of these colours has much strength in the composition, but I put them in anyway. The worktop was a piece of blueish marble, for which I used a very thin wash of Cerulean Blue.

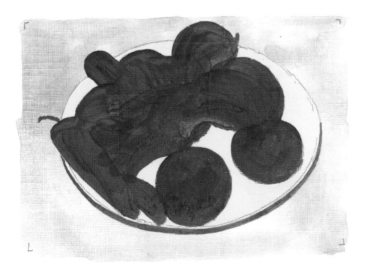

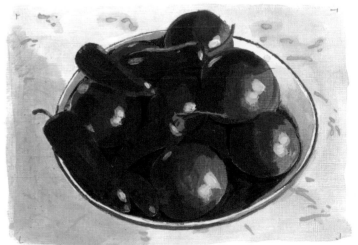

1 To start with, I just painted in the basic local colours of the objects and background. This at once showed me what the relative strengths of each colour looked like against the others. The red I used as a basis for the bright vegetables was Vermilion, which is a very bright, slightly orangey red. I put in the stalks of the peppers with Hooker's Green

2 Now I had to define the picture carefully with additional stronger tones of colour. These would begin to show how the dimensions of the shapes worked and indicate how they caught the light and cast shadows. I marked in the dark, veined faults in the marble with a thin mix of Light Violet and Cerulean Blue.

Next I put in a stronger red – Quinacridone Red Light – over the darker areas of the tomatoes and peppers. This accentuated their shape. I put in the dark tones of the bowl with a mix of Dioxazine Purple and a touch of Burnt Umber Light. This helped to define the shape of the vegetables and the bowl itself. With a touch of Titanium White, I marked where the brightest points of highlight showed on the rounded objects. For the even darker red on the shadowed parts of the vegetables, I used C.P. Cadmium Red Dark. To finish this stage, I put in the fairly light shadow cast by the bowl on the surface of the marble top using a diluted mix of Cerulean Blue and Dioxazine Purple.

3 Now it was obvious how the picture was beginning to take on form, colour and tone and becoming more three-dimensional. The next stage was to take the quality of the modelling and colour values further, so that the bowl of bright objects would start to have a life of its own. Up until now, I had been using brushes of size 10, 8 and 6 for the large brushstrokes, but I would need to turn to sizes 1 and 0 for the more detailed work.

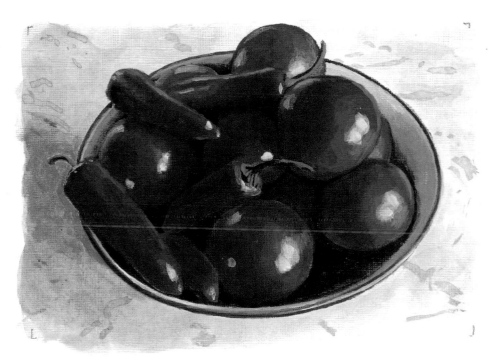

I felt that the tomatoes needed to be less crimson, so I washed a thin layer of C.P. Cadmium Orange over them, which immediately made them look different from the more crimson peppers. I softened the shading and tones of the rounded fruits until it looked less crude and the edges melted more into one another. Then I worked on the highlights, making some less sharp by floating a thin layer of red over them and others more defined by building up the white.

I worked on the darker shadows of the bowl and the cast shadow on the marble top. Up until this point I had used no black in this composition, but now I added tiny touches of Carbon Black in the very darkest parts of the shadows to deepen them.

At this stage, you need to step back from every painting you do and take an overall view, looking for any parts that don't quite add up. Are the tones sufficiently dark or bright? Are the edges of objects smooth or textured enough? Is there any one part that doesn't seem to fit in with the whole? If so, what should you do about it? The painting may need only tiny changes that hardly seem worth bothering with, but if anything stands out as not quite right, you should try to improve it.

If you have followed my steps through this painting, you will have learnt a lot about the qualities of acrylics. Even if your first attempt is not quite what you might have hoped, it will truly help with your ongoing artistic development.

A more complex still life

Next we look at a composition that is more complex and requires more forethought. The arrangement I have set up is a mixture of objects that give different qualities of texture, colour and shape to play with: a green glass bottle, a large dark ceramic bowl with three lemons in it, a small dark green ceramic jug, a small oval black bowl with three eggs in it, and a lemon with the end cut off to show the flesh.

I placed the big bowl in the middle of the composition and considered where to put everything else in relation to it. The green bottle looked good on the left of the big bowl and the small bowl with the eggs overlapped both of them effectively. I put the dark green jug to the right and the cut lemon in front of the small bowl, so that its brightness and that of the lemons in the large bowl formed a pattern against the darker tones of the other objects.

I covered the bottle with a wash of Permanent Green Light, the large bowl with Burnt Sienna and the lemons with C.P. Cadmium Yellow Light. I painted the small jug in a mix of Yellow Ochre and Hooker's Green Hue. For the small bowl, I mixed Cerulean Blue and Burnt Umber Light, producing a grey tone. I painted the eggs with a wash of Burnt Sienna. Now the whole area of the composition had colour on it, making it easier to put in the correct tonal values as the painting progressed.

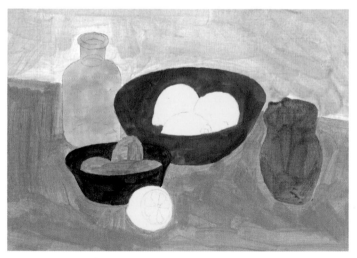

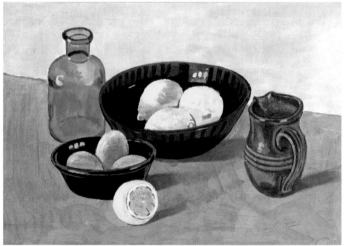

1 Once the arrangement was in place I could start putting on the basic colour. I covered the background wall with a thin wash of Burnt Sienna and Yellow Ochre, but so pale that it was only a light tone. The tabletop is a mix of Yellow Ochre and Hooker's Green Hue, strong enough to make the wall look even paler.

2 Next I began to define the objects more precisely, starting by using some Hooker's Green Hue and Light Green (Yellow Shade) on the bottle. I put in the highlighted areas with a little C.P. Cadmium Yellow and Titanium White. Then, using Carbon Black, I painted in the main colour of the smaller bowl and the black patterning on the big bowl. I used Hooker's Green Hue for the

darker areas on the jug, and Titanium White for any highlights on the jug and bowls. The lemons needed a little diluted Burnt Sienna and Light Green (Yellow Shade) to give them their lemony appearance, with some touches of Hooker's Green Hue and Yellow Ochre to add defining marks.

Turning to the eggs, I laid a mix of Light Violet and Cerulean Blue and some Titanium White, thinly overpainted, to lighten them up a bit. To finish this stage, Light Violet and Burnt Sienna made the faint shadows cast by the objects on the tabletop.

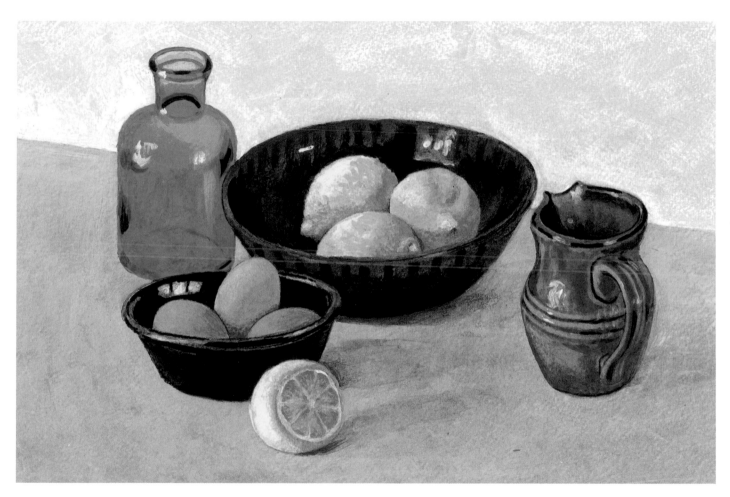

3 As before, in the last stage you may have to look more and paint less in order to get the effect you want. This is where the detailed brushwork comes into its own, and sometimes layers of lighter washes over the top of basic colours can produce subtler colour values. Working into your picture in detail will give you the qualities you want to show and help to produce a really strong still life picture. You may need to make lots of quite fine marks, some of them hardly noticeable except in the overall look of the composition. Keep working on it until

nothing interrupts your gaze as it passes across the whole painting – if you can't see anything wrong, it must be right, and you have finished. To complete my painting, I increased the details of colour within the main areas and softened areas that should look rounder. In some places I put light tones of colour over the main area of colour to warm it up or tone it down – on the eggs and the dark bowl, for example. I worked numerous small marks of tone and texture into the lemons and the green jug until I felt they looked more convincing.

A simple landscape

Landscape is a tricky subject because you have to decide exactly how much to paint of the view in front of you. To make things easier, it's best to take one tree or bush and concentrate on making that work in a space before embarking on a more ambitious project. It will also teach you about painting vegetation, which usually makes up a large part of a landscape picture.

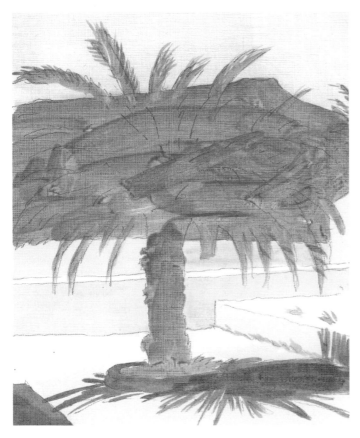

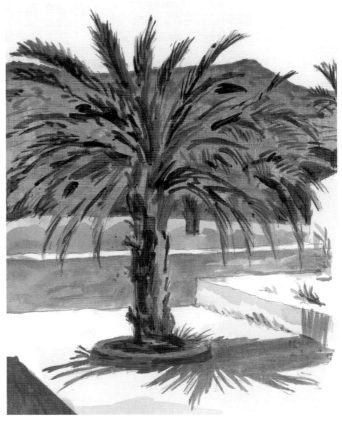

1 Here I selected a single palm tree in a Spanish street, which seemed strong enough to make a decent picture. I drew a faint pencil outline of the tree and the area around it, then began to put in the colour. The sky was washed in with a faint tone of Cerulean Blue and the main area of tree and distant background were washed in more heavily using Hooker's Green Hue and Yellow Ochre. The near background and foreground were washed in with Yellow Ochre and C.P. Cadmium Yellow, with the shadows in a light mix of Dioxazine Purple and Burnt Umber Light. The scene was now set for the next stage.

2 I decided that this painting would be Impressionist in style, with little or no detail. The success of this would depend on the earliest marks I made. I kept them flexible, conveying the feel of the foliage rather than trying to paint each detailed branch and leaf, using quick flicks of paint to put in the main areas. I added darker tones of green and brown, then lighter green and yellow where necessary, using the colours you are familiar with from previous exercises (see if you can work out which they are). Lastly, I made the purple shadows on the dry ground a little bluer.

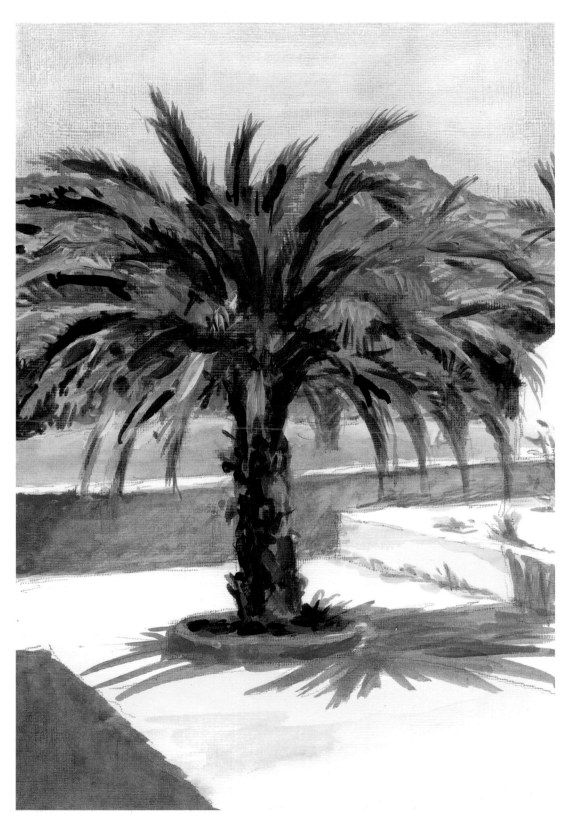

3 In the final stage I put in the details that were going to enhance the whole picture with a little more precision. These marks sharpened areas that needed it and softened other areas that were too prominent; I achieved this with a mixture of washed-on overlays and small solid marks of colour to add intensity and power to the final picture.

A sea cove landscape

The next piece of landscape painting in acrylic is of a cove on the coast of Majorca, a Spanish island in the Mediterranean Sea. This view in the hot southern sunlight brings out the strong, vibrant colours of the sea under a bright blue sky.

1 As before, I began by putting in the main areas of colour, but in a very pale tone of each one. The sky is a wash of Cerulean Blue, as is the foreground sea, but here it is broken up to show the bright sparkle of the sun on the waves. The far-distant sea looks much deeper in colour, so I used a more intense Cerulean Blue to show that. Much of the rocky coast is in pale Yellow Ochre with some touches of Light Green (Yellow Shade) and Dioxazine Purple for the shadowed areas. There is a touch of mixed Cerulean Blue and Yellow Ochre for part of the sand and one area of rock.

2 Next I put in some extra Ultramarine Blue for the darkest tones of the sea and added some Burnt Sienna touches over parts of the rocky headland. I added some Light Green (Yellow Shade) to the patches of the sea within the bay, and some touches of mixed Light Violet and Burnt Sienna on the areas of sea closer to the beach. The trees and vegetation gained some touches of dark green to show areas of shadow, while numerous little scribbles of darker blue helped to define the waves in the bay.

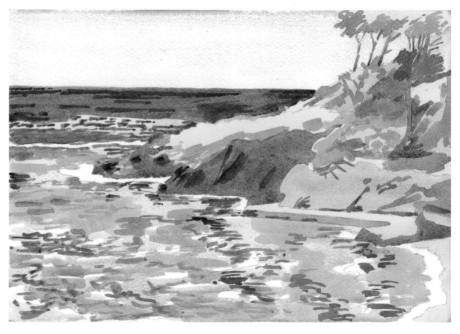

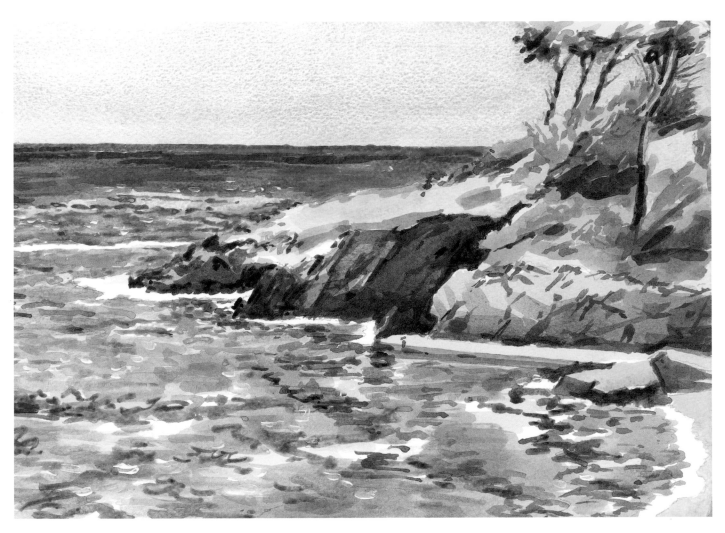

3 Finally, I looked carefully at the intensity of colour and tone and added whatever seemed necessary to make the composition come to life. I found I had to wash quite a bit of yellow and light green over the nearer parts of the sea to make it look more like the actual scene. Then the darker shadows cast by the rocks needed to be put in as precisely as possible to suggest the jagged

nature of the coastline. I felt I could have worked on this landscape for quite a while longer, but my companions had decided to have lunch at another location and I was obliged to stop sooner than I would have wished. Even so, the painting seems to have caught something of the place – its intense, brilliant colour and well-defined shape.

The wider view

This landscape is in England, near the Waterperry Horticultural Gardens in Oxfordshire, and the view is across the River Thame showing a partly reaped field of hay.

1 I sketched the main outlines in pencil, as I would with a watercolour. Then, as before, I began to put in the main areas of colour. I made the sky a pale grey-blue, the grassy areas pale green and the other areas of plants and grasses a sort of brownish-purple, painting them all in very thin washes of colour. I won't tell you the colour names on the tubes of acrylic paint this time, but will leave you to guess which colours I used. This is a good test of your ability to recognize colours, and even if you don't use exactly the same colours as I did, choosing your own is how you learn about painting.

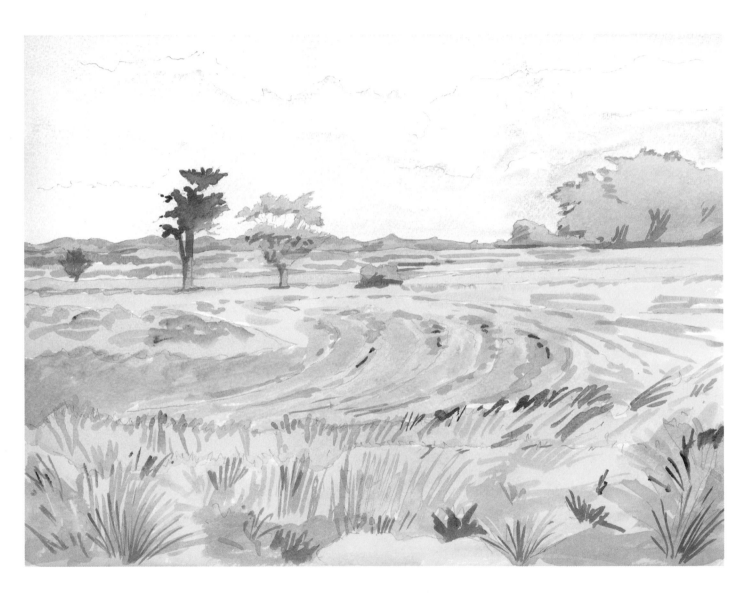

2 Having covered the paper with paint, even if rather lightly, I could now use stronger variations of the colours to help define the textural look of the landscape. Some parts, such as the trees, had to stand out more clearly, and the foreground plants needed to look more definite and be in stronger colours than the background and middle-ground colours and shapes. Purples and bluer colours helped to push the background further away, while warmer browns and yellows brought the foreground closer.

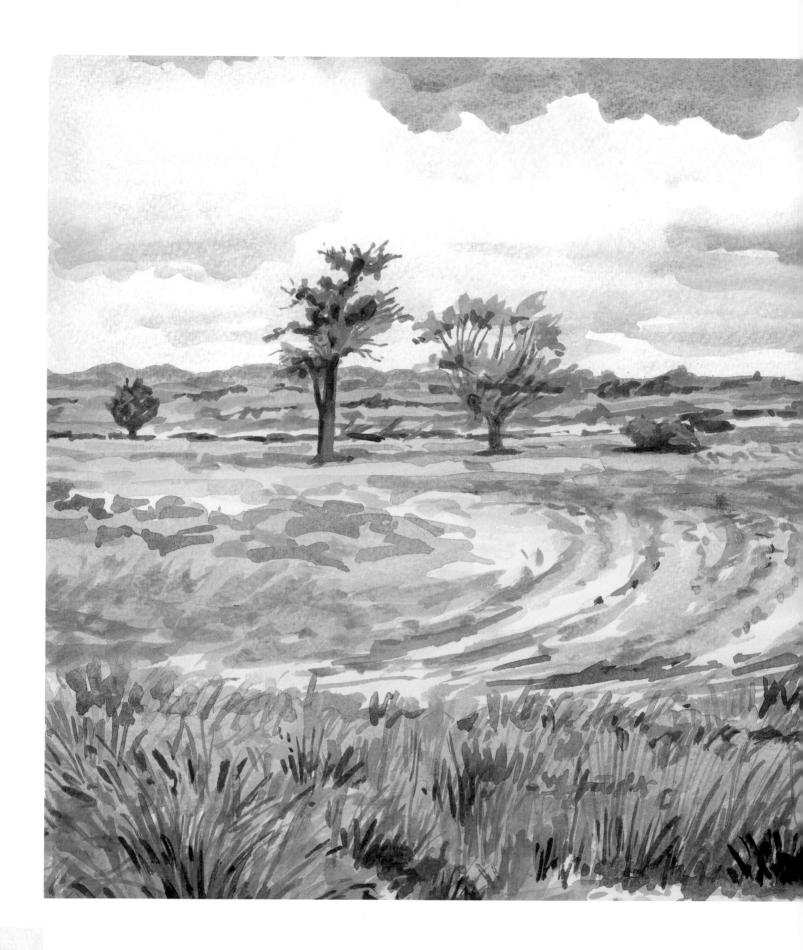

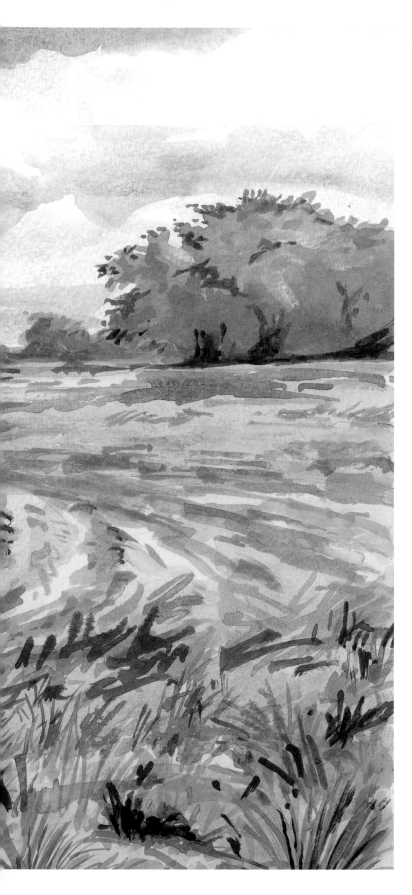

3 For the last stage I began to beef up the texture and colour of the landscape and added all the small details that would make it look more convincing. Numerous small areas of shadow helped to make the trees and bushes look more solid and three-dimensional, and some stronger overlays of colour made the tones and colours look more natural. Where I wanted colours to merge well, I put wet colour onto wet colour, and where I preferred them not to merge, but to change the overall colour, I waited until the first colour had dried. As usual, I stepped away from the painting to see what final details and adjustments might be necessary, a process that means more time spent looking and thinking than painting. Never neglect this stage, as it's part of the way in which an artist finds how to make the composition just that little bit more significant.

Portraits

The real challenge in painting a portrait is that everyone who knows the subject can see whether or not you have managed to make the person recognizable. As we saw in the section on painting portraits in watercolour (*see* pages 30–33), it's a good idea to work first from a photograph. This cuts out all the problems of getting the proportions correct, as you can measure them in a photograph much more easily than you can from real life. At some time you will want to progress to working from life, but this is easier to do once you are more proficient, not least because you will feel more confident with your model.

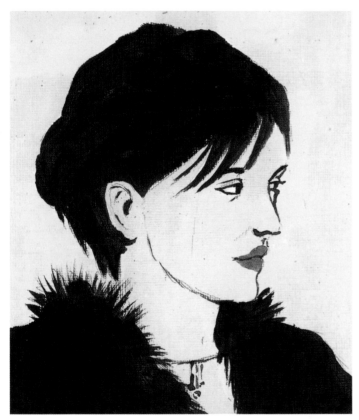

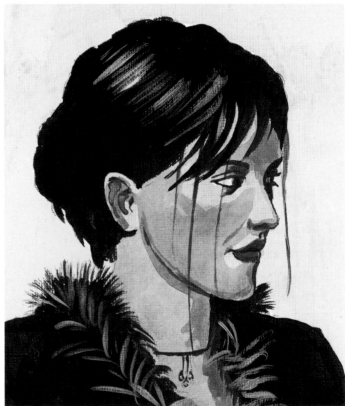

1 The first portrait is of a young woman who came to my daughter's wedding – a girl with her hair in some long strands at the front and the rest tied up behind. She had healthy colouring and dark hair and in the first step I just blocked in the main colours with a strong contrast between the skin tone and the dark hair and dress, using complementary colours of yellow and violet. At this stage the main features had to be accurate, but a bit simplified, like a cartoon. You don't need

to be too subtle at this stage as long as the form is well expressed – if the features aren't quite right, correct them now, and paint out the corrected lines and shapes later on.

2 Next I put in stronger tones on her hair and dress, adding some blue to show the gloss on her hair and the fur around her neckline. I delineated her features more carefully, making them more realistic.

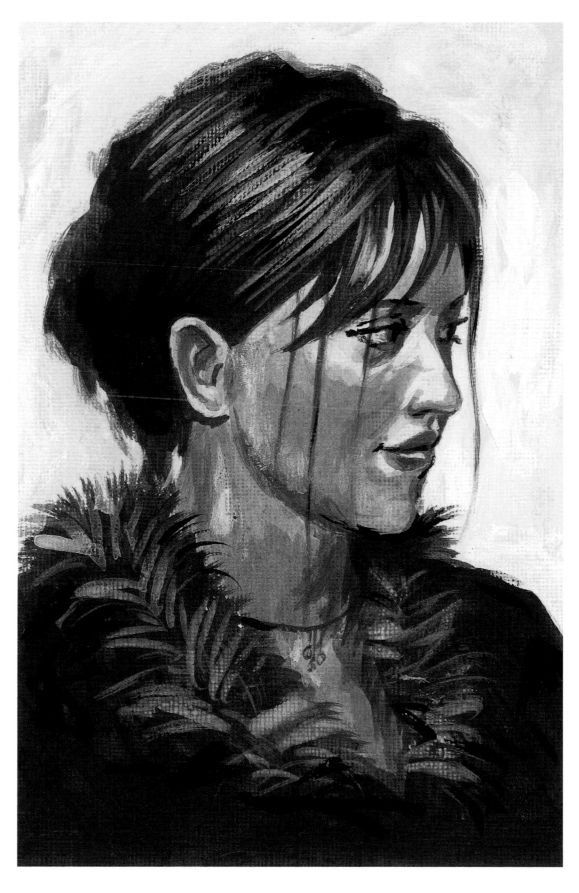

3 Then I made the colour stronger so that the form became more natural and three-dimensional. The background is important at this stage because you need to get the balance with the face right in terms of colour, tone and texture. It was also time to get the likeness of the subject's face precisely and make her very recognizable.

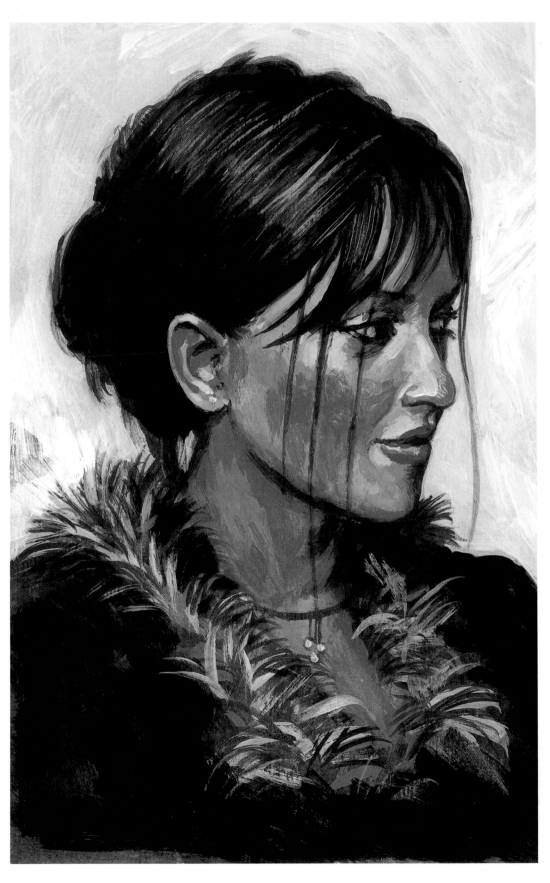

4 Finally I began to work on the more subtle aspects to render the facial features soft and natural, so that my subject looked like a real human being rather than a doll. At this stage you can apply paint much more thickly to allow the marks to mould the dimensions of the head. Distinct, clear brushmarks can be an added advantage here to give the effect of a lively person. Time taken working over the picture now, making sure you have captured a good likeness, can be very valuable.

Three-quarters portrait

Here is a three-quarters portrait of one of my grandsons. He is shown in a room with dark walls so that he stands out lighter against the gloomy background.

1 The first step was to draw an outline in pencil and then lay in the main colours as before. The background is a mixture of Burnt Umber Light and Dioxazine Purple; the jacket is Cobalt Teal and Permanent Green Light, with the trousers a washed-out Ultramarine Blue and the T-shirt in a mix of Burnt Umber and Ultramarine, with the blue dominant. The hair and face are in washed-out Yellow Ochre and Burnt Sienna respectively.

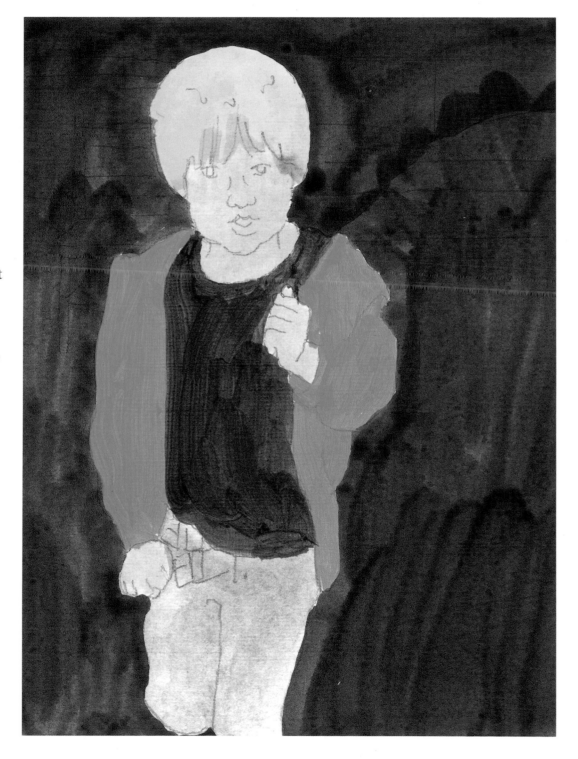

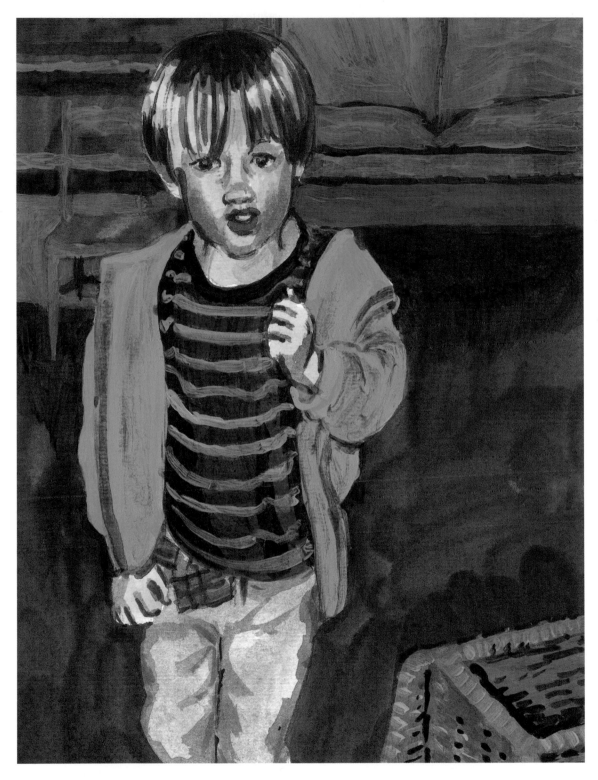

2 At the next stage, a lot of working on the tonal values was necessary and some details of the dark background were defined more clearly. I didn't allow the background colours to get too bright, as I wanted it to recede behind the figure and let the liveliness of the child stand out. I put in such things as the stripes on the T-shirt, the texture on the foreground basket, and the light and shade on the clothes, face and hands. I also washed a layer of lighter brown over the foreground floor.

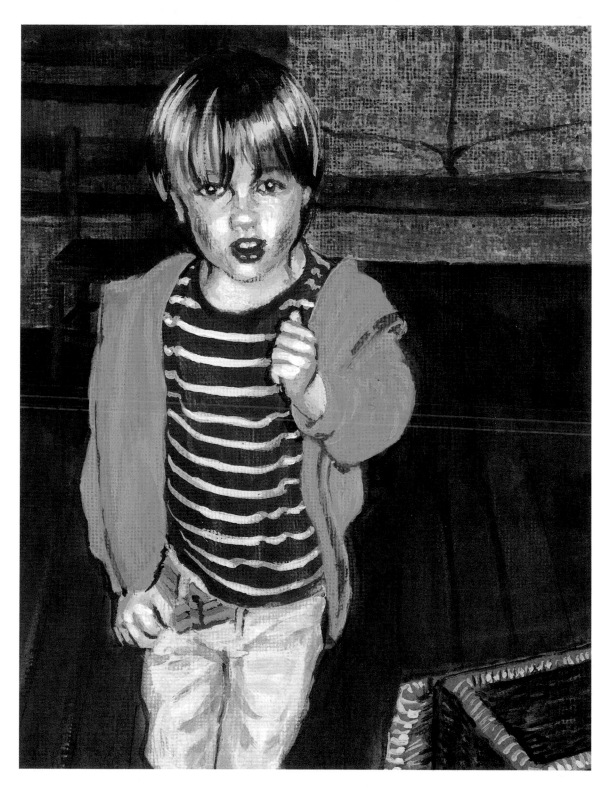

3 Next came the final defining of the picture, especially the facial features, so that the face was recognizable. I added more details to the background without making it too strong, then refined the shapes and folds of the clothing, the belt and bright stripes on the T-shirt and the small details of the basket in the foreground. Finally I put in the very brightest highlights, where necessary, to bring the picture to a conclusion.

Simple figure composition

Painting figures is always difficult because we all know when the human body doesn't look right in a picture. So, to make your first experiment in figure composition much easier, it's best to rely on photographs. For this exercise I decided to use a photograph I had taken when on holiday with my son and his family. I had already worked out the composition when I took the shot, and I just needed to copy it well enough to make it look natural.

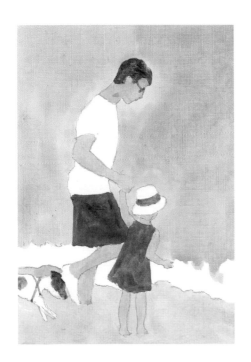

In this two-figure picture, my son is holding his small daughter by the hand on a Mediterranean beach. All the background is formed by the sea, with a small patch of sand at the base of the picture. There is a small dog following along behind.

1 To start with, I painted in the sea with a simple, strong wash of Cobalt Teal, stopping a short way from the shoreline to leave a strip for the white surf. The shore was painted with a thin wash of Yellow Ochre. I put a warm tone of pale Burnt Sienna on all the areas of skin on the two figures and used a less diluted Sienna for the dog's brown patches. I put my son's shorts and his daughter's dress in a wash of Ultramarine Blue. Then I painted in his hair and the texture on the beach with a pale version of Burnt Umber Light.

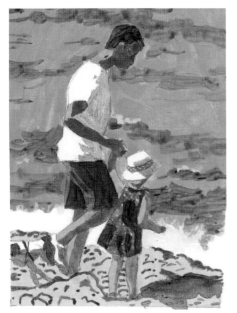

2 Next I began to add some shadow to give the picture depth. I used a much paler version of Ultramarine Blue for the shadow on the shirt and hat, then a darker tone of Burnt Sienna for the shadows on the skin. I put in some darker blue for the shadows on the shorts and dress and added the pink strip on the hat with diluted Quinacridone Red Light. I put in some dots of Titanium White on the dress and hatband and added an indication of white surf. Then I laid in some additional splashes of darker Ultramarine Blue and Permanent Green Light on the sea to suggest waves.

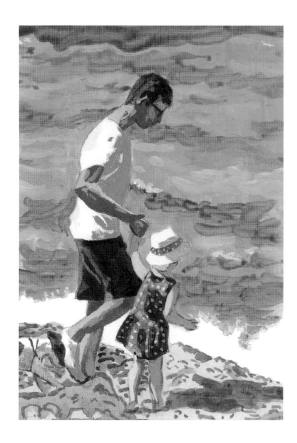

3 I blended the shadows on the skin with touches of Light Violet mixed with Burnt Sienna, then put shades of Sienna on parts of the sandy beach and darker tones of Burnt Umber on my son's hair and skin and the dog's brown patches. I used even darker tones for the shadows on the dress and shorts, and a mix of Burnt Umber and Ultramarine Blue on the sunglasses.

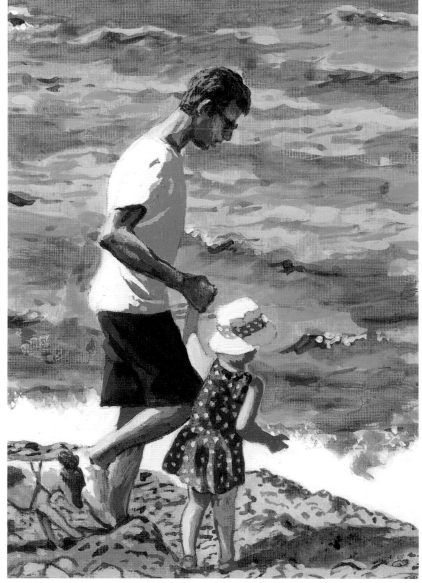

4 In the final stage I worked up the more shaded parts of the figures to give greater definition to details and softened some of the shaded dots on the girl's dress and hat. I also worked the sea over a bit with sharper touches of dark blue and green and added extra touches of Titanium White for surf on the crests of the waves. I made more subtle variations in the skin colours where the tones melted into one another and made the girl's legs look more solid. Finally, I pointed up the darker areas of the shorts and dress with a mix of Ultramarine Blue and Burnt Umber.

A more complex figure composition

This composition also has only two figures, but the background is much more complicated in both colour and form. The figures are mainly in shadow against a varied background with strongly contrasting tones. Even these parts are broken up with different colours which creates a sort of mosaic of shapes and colours against which the figures have to stand out. However, moving from a simpler composition to something a bit more complex should not give you too much difficulty if you tackle it stage by stage.

1 I put in the main colours of the two people first, making sure that they were strong enough to present dark figures against the background. Then I put in the background colours. I made all the colours slightly lighter than I envisaged for the final picture in order to make subtle adjustments of tone and colour later on. I will leave you to judge for yourself the exact colours I have used.

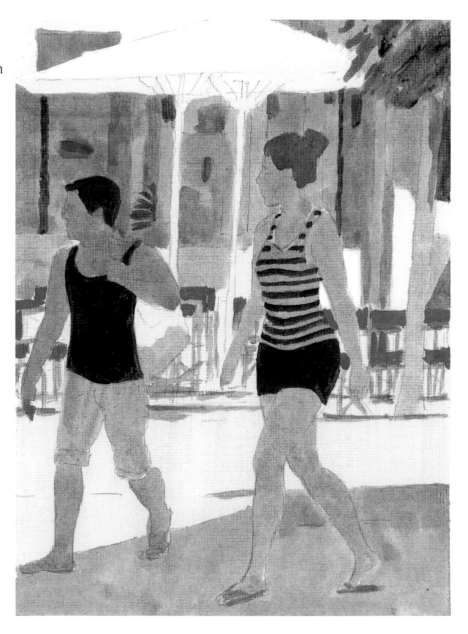

2 Next I defined the colours further and made sure the shapes were correct. The darks that really stand out were strengthened and the lighter splashes of sunlight were made brighter to create a strong contrast between dark shadow and bright sunlight. I worked on the broken background in the shadows until it began to look more definite, but kept it all still in shadow.

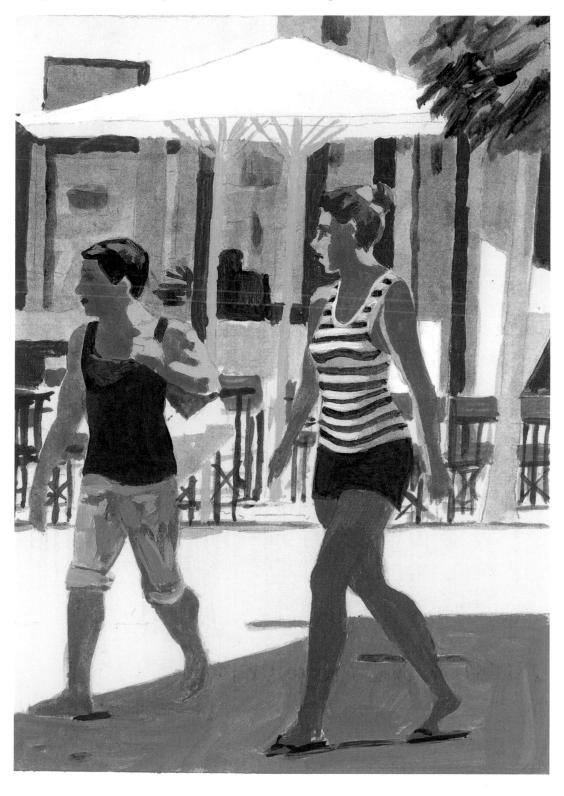

3 Finally I sharpened up the detail, especially where it helped the figures to stand out against the background. This was a real balancing act between colour contrast and merging tonal areas. The last touches were the whiter, brighter areas and the darkest tones.

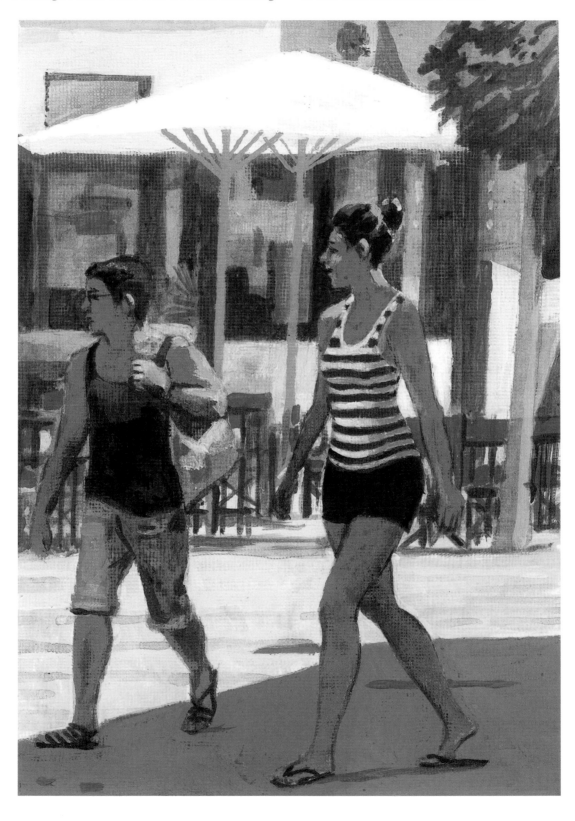

Life painting using impasto technique

To use acrylics more like oil paint, you can work in what is known as impasto technique, laying on the colour thickly so that it blocks out the colours beneath.

1 First I covered the whole surface with a layer of Burnt Sienna. When that had dried, I took a thin brush and drew the figure in outline, keeping it as simple as possible.

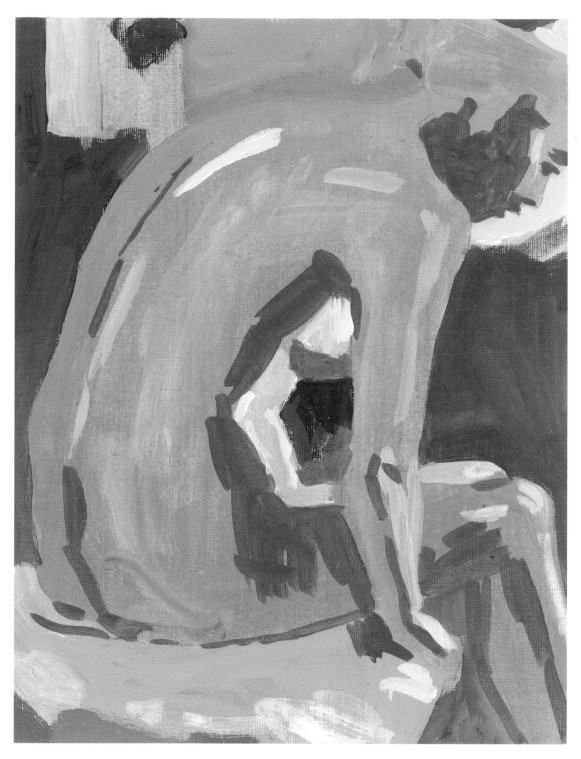

2 Once the outline was dry, I began to lay on the paint in thick, almost solid layers, allowing the brushstrokes to show as they may. I blocked in the main colours of the background first, so that the figure began to stand out against it. These colours are mostly variations in greys and browns that come from mixing complementary colours. Then I put in the brighter and darker parts of the figure to begin to give some dimension to the outline. These colours are variations on light purples, blues and yellows.

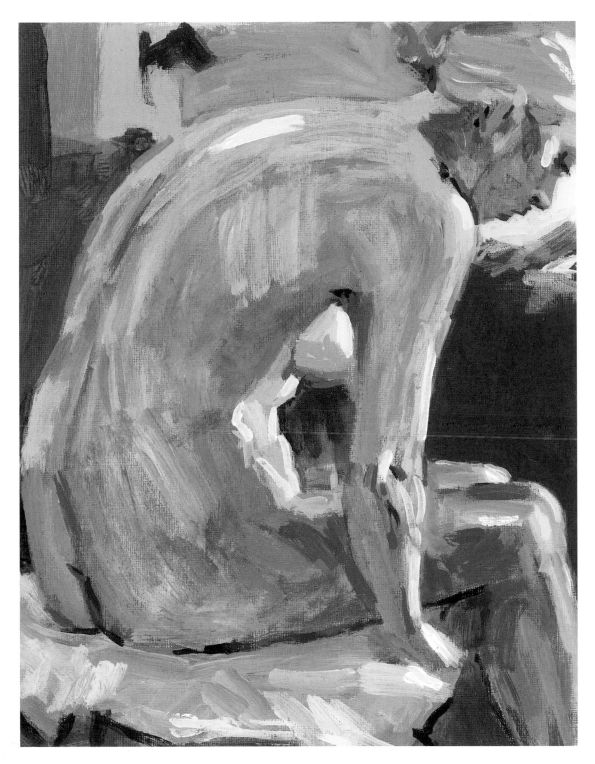

3 With the main shape and colour of the figure marked in, I could now begin to paste on the paint as thickly as I liked, so the texture of the brushstrokes would help to build the solidity of the body. I gradually added darker and brighter marks to give the form more solidity and sometimes smudged layers of paint over tones already present, softening the edges a little to help the impression of roundness. When you are working in this style, don't try to put in much detail because this will reduce the power of the larger brushstrokes and the form will lack boldness. Finally I put in the very brightest highlights, where necessary, to bring the picture to a conclusion.

3 Oils

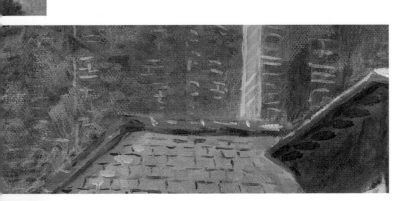

For me, oil paint is the best medium. Not everyone shares my opinion, of course, and many artists prefer to use watercolours or acrylics. However, oil paint has so many applications that I see it as the most flexible medium and it offers a wide range of colours of great power and subtlety. It also has the additional value of being more or less everlasting.

Many people are reluctant to start painting in oils because they think it will be too difficult. However, once you take the plunge you will find it only takes a very short time to get used to it and then it's not hard at all – and it has the huge advantage that if you make mistakes you can simply cover them up or scrape them off before they dry.

You will find the basic materials described on the following pages, but remember there are lots more colours and implements available for you to try out. Learning to handle the paint and the medium takes a little longer than the previous methods shown, but once you have picked up the basic method, you will be able to expand your activities into many ways of producing art. Oil painting is one of the most satisfying things I have ever discovered to do. I hope you find it the same.

Preparation and equipment

As with all art mediums, you need a minimum amount and standard of kit in order to make a start – but a good and determined artist is never at a loss, even if the right materials are not at that moment available. You will need some sort of palette on which to mix your oil paints and you will find a choice of these in art shops, but a piece of board, plastic or glass can be drummed into service if need be. The illustration here shows a typical varnished wooden palette, with a thumbhole to make the palette easier to hold at a convenient level. If you are buying a palette, start with a small one and scale up as your confidence increases.

You will also need two receptacles for your thinning mediums, such as turpentine or white spirit. Ordinary jam jars will do for this purpose, but there are many alternative containers, as long as they are easy to clean and will hold the spirit properly. In art shops you can buy dippers – small metal containers with a screw top and a bracket underneath by which they can be attached to the palette.

Oil paints are pigments suspended in drying oil (usually linseed), often with other solvents or varnish added. Except for those with added driers such as alkyd oil

paints, which may be dry in about 12–15 hours, most oil colours take at least a week to dry. They come in tubes of at least three sizes and you can decide for yourself the size you want of each colour. As I use more white than any other colour, I always buy the largest tube possible since this is by far the most economical option. The main thing to remember is that you should choose good-quality brands and always the artists' range, not student quality. While they will be more expensive, artists' paints generally go further as they are more pigment-heavy, so the difference in cost is not as great as it appears. Any good art shop will give you advice if you are unsure what to buy.

Then you will need paintbrushes and palette knives – start with just a few until you discover which sizes are best for you. I always have at least five sizes and shapes of hog-hair brushes and about three or four fine-pointed brushes, usually of sable hair, in small and medium-large. I mainly use two palette knives, a long-bladed one and a smaller pointed one.

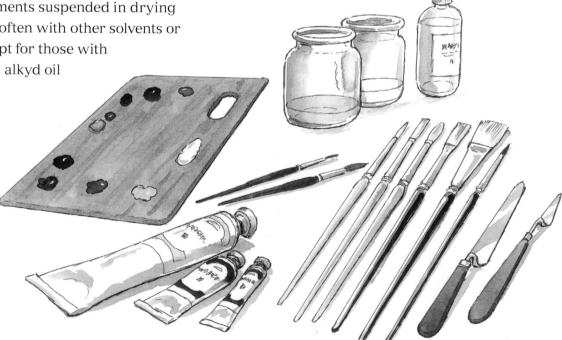

Supports

For a support, or surface, the obvious choice is canvases, and these are easy to obtain in many sizes and in rectangular or square format. They come in traditional depth or with a deeper edge to suit the modern style of hanging canvases without a frame. A piece of board, such as MDF or plywood from a timber merchant or DIY store, is an inexpensive alternative, though you will need to coat it with a primer such as gesso before use. You can also buy canvas paper in pads which can be stuck to a board to paint. The illustration shows a piece of board being coated in white gesso, a canvas covered with a glaze of Burnt Sienna and a pad of canvas paper.

Most 'stretched' canvases (meaning they are stretched on a wooden frame) use cotton as the cloth, but you can also buy linen, at a higher price. If you really take to oil painting you can explore a much larger variety of cottons and linens sold by the metre or roll, and the supplier will usually do the job of stretching it for you if you don't want to do it yourself.

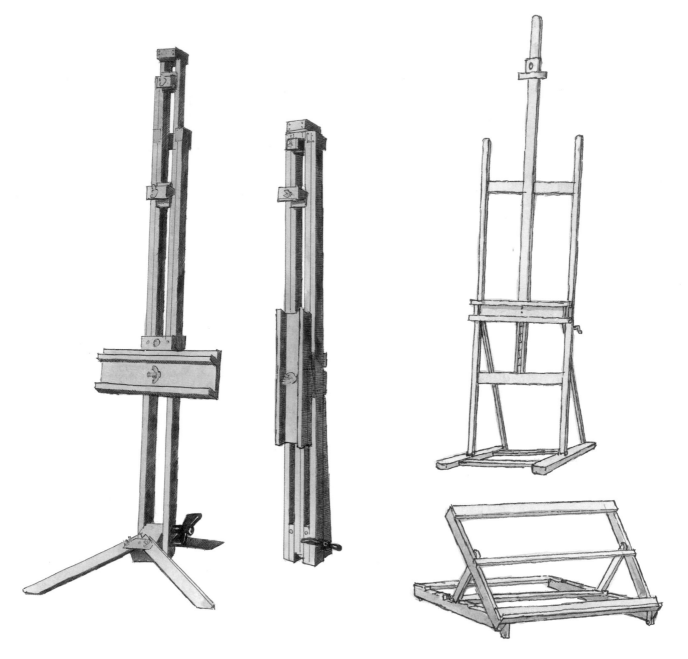

Easels

If you are going to take painting in oils at all seriously, you will require an easel. Table easels (above right, bottom image) are suitable for small paintings and are easy to obtain at low cost, making them ideal to start with. However, if you are working on a larger scale you will need to invest in an upright easel. The heavy-duty (and heavy) H-frame studio easels that can take very large canvases tend to be pricey. The radial easel type (above left) is a lot less expensive and can be folded up to store or carry, which makes it the most useful if you are short of space.

In between, in terms of price, are H-frame easels for canvases of no more than about 127cm (50in) tall (above right, top image). These often come with a ratchet device for raising and lowering the shelf that supports the canvas; you may find this easier to handle than the screw attachment on radial easels and some H-frames. You can also find H-frame easels with castors, so although they take up more space than a radial easel they can easily be pushed aside.

Colours

As you gain experience, you will want to try a range of colours and find your favourites, but I have found that with the colours shown here you can paint almost anything you see. Mixing complementary colours such as red and green or violet and yellow will give you a wide choice of neutral greys and browns. Using these, you can easily change the colour bias and alter their tone by adding white.

Naples Yellow	Flesh Pink	Alizarin Crimson	Cerulean Blue	Permanent Green Light	**You will also need:**
Cadmium Yellow Light	Cadmium Orange	Dioxazine Purple	Viridian	Olive Green	Titanium White
Yellow Ochre	Scarlet Lake	French Ultramarine	Permanent Sap Green	Burnt Umber	Lamp Black
					Burnt Sienna

Techniques

By this stage you are ready to start – with all your equipment to hand and some knowledge of how to use it – and now you have the challenge of actually applying paint to a blank surface. You may already have some experience with other mediums, but even so, many artists find a first encounter with oils and canvas, the materials used by the Old Masters, somehow more daunting. In fact, because you can scrape or wipe oil paint off, or simply paint over your mistakes, you will find it a very forgiving medium to work with.

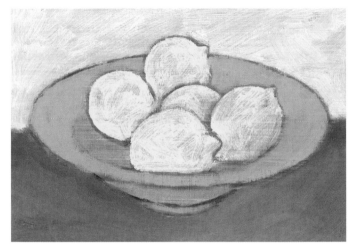

Laying a ground

Most artists don't like to paint directly on to a white canvas because the intensity of the contrast between the canvas and the colours as they are applied make it difficult to work out the balance of tones. To avoid this, they usually cover their canvas with a neutral mid-tone colour, such as a brown or greenish-grey. This is known as a base colour or 'ground'.

Here is a canvas board covered with a thin layer of Burnt Sienna, which is the base colour that I often use before painting. This will have to be left until it is dry, which with alkyd oils is about 12 hours. Other oil paints take longer, but you can also use acrylic paint as an under surface as long as you don't apply it thickly.

1 The colour of the ground will influence the final painting. In my examples I've painted the first surface with Terre Verte (above), which is a cool grey-green, the second with Burnt Sienna (top of facing page), and the last with a dark colour made by mixing French Ultramarine and Burnt Umber (bottom of facing page). So one has a cool background, the next a warmer background and the last a very dark background.

2 Once the base colour had dried I painted my still life of five lemons in a green bowl, first outlining the shapes in a dark tone, then blocking in the main colours with quite thick paint. I used exactly the same colours for all three versions. These are not the finished paintings – just the first attempt to show the colours of the objects correctly.

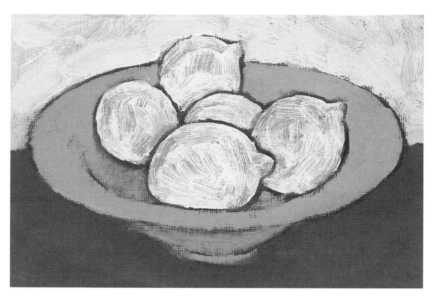

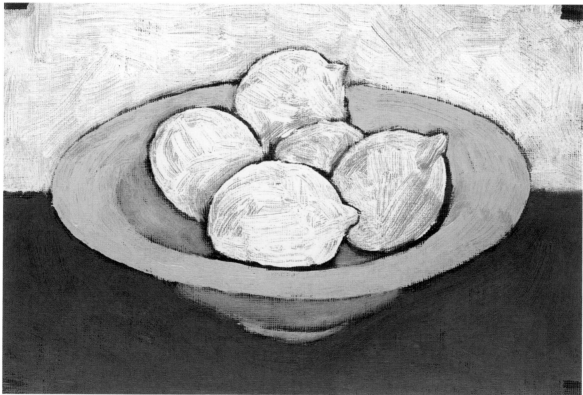

3 What is immediately noticeable is that the three pictures are all subtly different: the first looks rather cool in colour, the second is much warmer, and the third appears more luminous. This is due to the background colours, which show through the paint and give a particular look to the picture. So from the word go you can influence the look of your painting by the ground colour you choose.

Of course to finish the paintings, I would put on more layers of paint and start to show more detail, which would have the effect of diminishing some of the intensity of the base colour. This means that eventually the three pictures would become more similar, but the base colour would still have a subtle effect on the final result.

Drawing with the brush

Once I have laid a ground I then draw on it an outline of the scene I plan to paint, using a brush – most frequently a small hog's bristle brush. At this stage I try to get all the main shapes in proportion and in the right place on the canvas. I can then start painting immediately on to the framework that is there in my simple drawing.

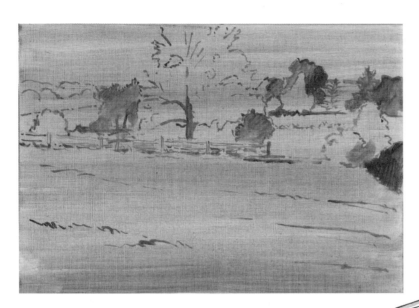

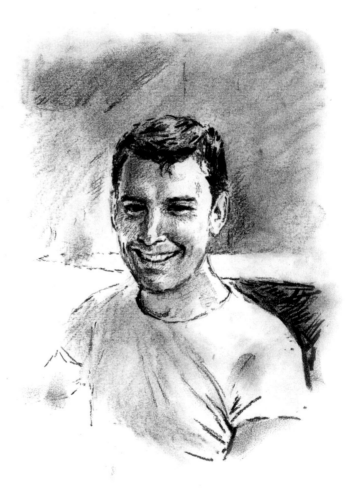

Charcoal drawing

1 Some people find that drawing with the brush is too inaccurate for their taste and prefer to draw out their subject first in charcoal. Unlike pencil, charcoal doesn't repel the paint when it is placed on top, and it's also a very flexible medium that can show all the tonal values that you might require.

2 Having done this, you will need to fix your drawing with a spray-on fixative. Use it outdoors if possible, because the spray is unpleasant to inhale.

3 The fixed drawing dries very quickly, and you can then brush over it with a thin layer of a tonal colour such as Burnt Sienna.

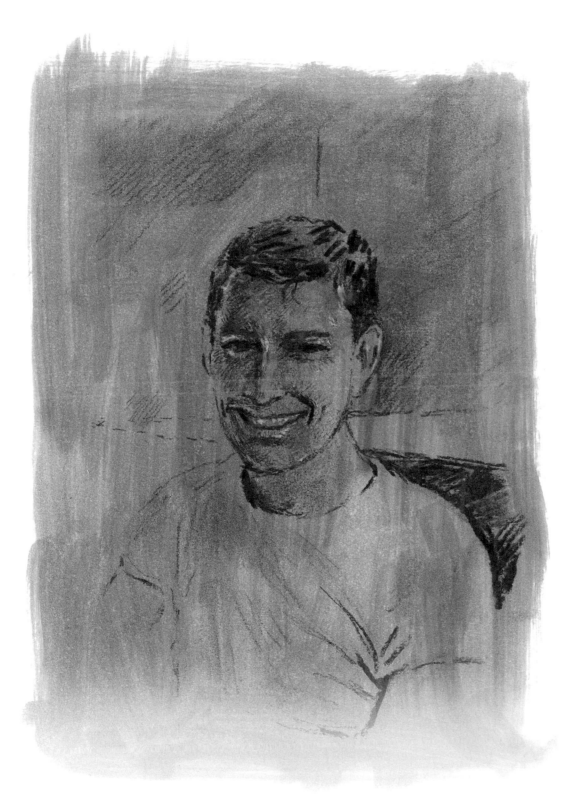

4 Once the ground is dry you will be ready to paint all your colours on to a complete drawing. This is a good way to start, though with time and experience you may discover your own preferred way of working. For example, I know a painter who always draws her subjects in great detail with charcoal then squeegees a layer of French polish across the drawing, which gives her a pleasing shadowy tonal and fixed surface on which to paint.

Still life

When you are starting to use oils, painting a still life is the easiest option. Your subject won't move or change, no matter how long you take over your painting, and you can choose whatever you want to include in your composition and arrange it as you wish. So here is a series of objects made of different materials, which are ideal for your initial attempts.

Pear

To start with, just choose a piece of fruit and paint that against a very simple background. As an example, I have taken a large, ripe pear standing upright on a dark surface against a neutral background.

1 The first step is to draw the shape as accurately as you can. I prepared the canvas with a thin layer of Burnt Sienna and used a brush to draw a strong line in the same colour. The undercolour makes it possible to work on a tone rather than try to match colours on a bright white surface.

If you are worried about painting straight on to the canvas at first, make a careful pencil drawing and then trace it on to the canvas once you are satisfied that it is the right shape.

2 The next stage is easy enough, too; it's just a matter of putting down a colour that gives a good general idea of the object without any influence caused by shadows or reflections. This is called the local colour. It's always advisable to put in colours simply at first because you can get a better idea of how the relative tones of the main ones react with each other.

In this case the background is a medium neutral grey made from French Ultramarine mixed with a little Naples Yellow and reduced with Titanium White, and the surface the pear is standing on is Burnt Umber. The pear itself is coloured with Cadmium Yellow Light mixed with a touch of Burnt Sienna and reduced just a little with Titanium White. I laid all these colours on quite solidly but allowed just a little of the undercoat to show through.

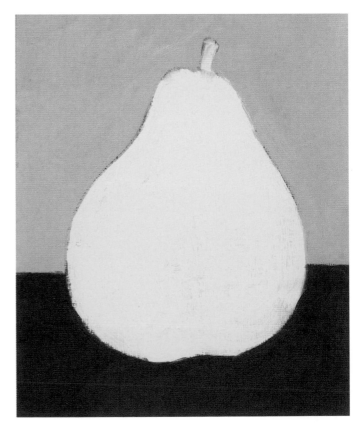

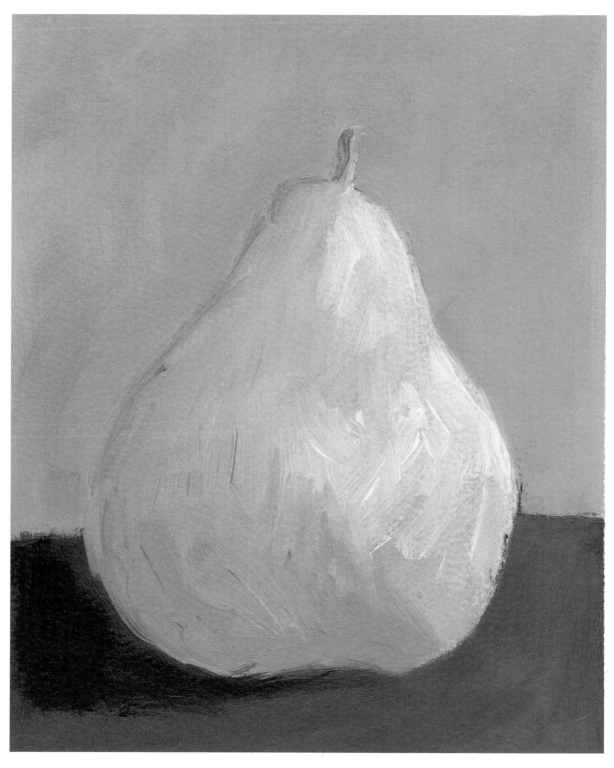

3 Next I added some tonal values to indicate the shape of the pear. A little Titanium White with some Viridian and a touch of Burnt Umber gave me the shadow on the pear, faded off from left to right. Then, with additional French Ultramarine, I put in the shadow cast on the wall behind, and with some French Ultramarine and Burnt Umber the dark shadow cast on the table by the pear. At this stage you may want to paint the areas where there's stronger light with the original colours, but this time mixed with a little Titanium White.

4 I began building up the tonal values on the surface of the pear to form its rounded shape, using a thin layer of greenish-brown made from Viridian mixed with some Burnt Sienna and a little Titanium White. I kept this thin so that the yellow showed through easily and made it slightly darker on the left side of the pear than on the right. On areas where the light struck the pear most strongly I avoided adding any tone.

Then I began to add in the darker brown marks speckling the surface of the pear. For this I used Burnt Sienna mixed with a little Naples Yellow, darkening the brown with a little Burnt Umber on the shaded side. To show where the strongest light fell, I put down some Cadmium Yellow heavily reduced with Titanium White. I also worked on the tonal variations in the background, adding a lighter version of the original neutral grey for the background and a mixture of Burnt Umber and Burnt Sienna for the lighter areas on the table top.

5 Now for the final stage, during which I looked very closely at the subtle tonal changes on the surfaces and softened the edges of the shapes or made them crisper where needed. I also worked on the details such as the stalk and the marks on the surface of the pear. The shadow closest to the base of the pear needed to be strengthened and I built up the whole area of shading a little, taking care not to overdo it. Little spots of green and brown speckled across the surface of the pear gave the effect of the skin.

At this stage stepping back from the picture is important, and you may often spend more time looking at your work than actually painting it. This is all to the good, though, because your judgement at this stage will make the difference between a piece of work you can be pleased with and one that falls short of your own standards. Time spent checking each detail is time well spent.

Glass

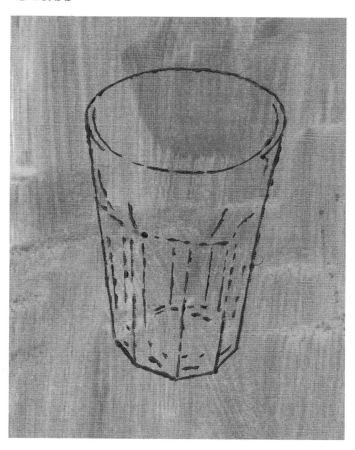

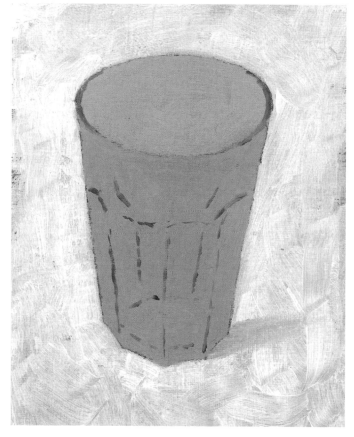

1 For this exercise, start with a simple glass tumbler. These are easy enough to find, and because you can see through them, understanding and drawing their form is quite straightforward. On a prepared canvas or board, outline the tumbler in paint with a small pointed brush – don't put in too much detail because you only need the main shapes at this stage. I have used Burnt Sienna for the wash over the canvas and the same colour, only stronger in tone, to draw with. Drawing with a brush like this gets you into the habit of using oil paint for every part of your work.

2 Next, block in the main areas of local colour with green made from Viridian mixed with Titanium White. Notice how the open circle of the top of the tumbler, where you see only one thickness of glass, can be significantly lighter in tone and colour than the rest of the glass. For this I added Yellow Ochre and more Titanium White to Viridian. I used darker pure Viridian for the strongest tones, such as around the lip of the glass and the angles. The background here is a cool, pale colour made mostly with white. Don't forget the reflected shadow of the glass on the tabletop.

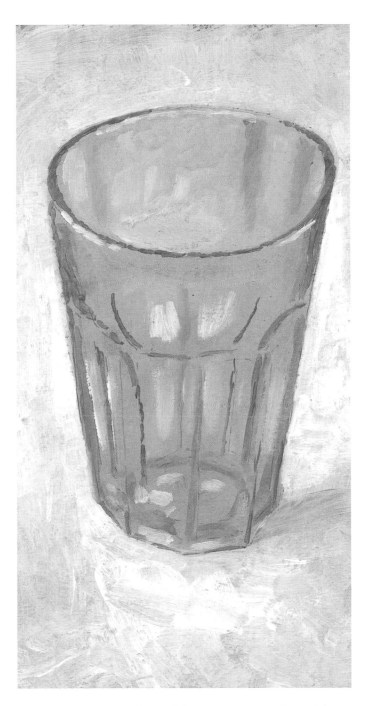

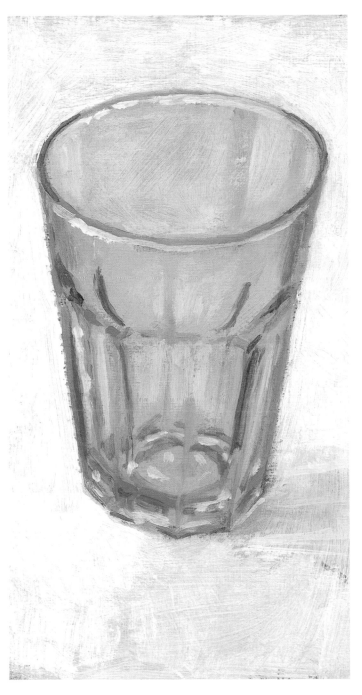

3 Now you need to add some extra colour for the darker tones and Titanium White for the bright highlights. At this point, brighten up the background, particularly on the side where the light looks strongest.

4 Finally, you need to put in the more refined details to show the deeper and brighter bits of colour you always find in shiny glass objects. This is quite good fun, and you will wonder exactly how much you have to do to finish the work. The answer is that when it looks as though there is nothing wrong, it must be right, and this means you have completed your painting.

Metal

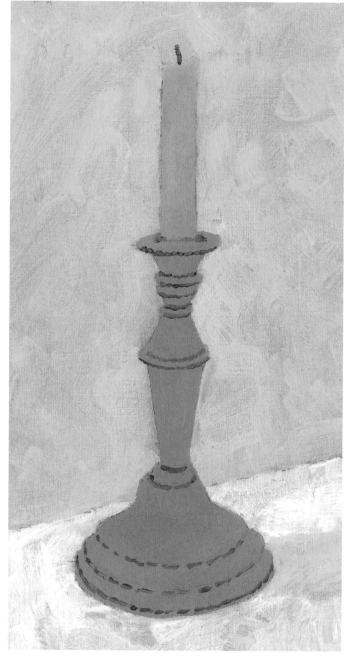

1 The next object is a pewter candlestick with a candle in it. If you want to give yourself a tougher test when painting a candlestick of your own, you could light the candle. Of course, you risk it melting right down if you take too long to finish. Again, start with a drawing in paint to get the correct shape of the object. Remember that it is a centrally designed object, so each side will be a mirror image of the other.

2 Now block in the main colours. These are mostly greyish tones made from French Ultramarine and Burnt Umber with Titanium White, some with a little Naples Yellow mixed in. When the main grey has been laid on, mark out the simple divisions of the shape – your underdrawing will probably be noticeable through the main colour. The background colours are very close to each other, but be sure to make them easily distinguishable.

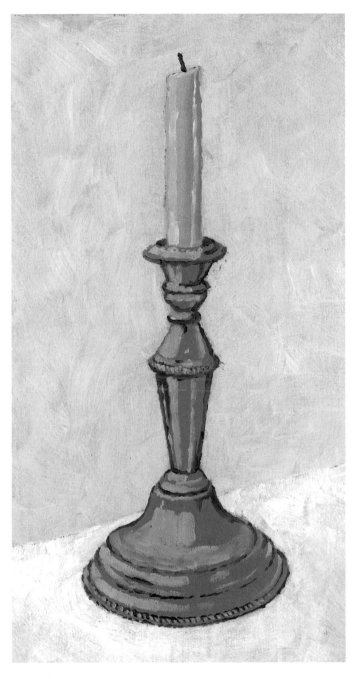

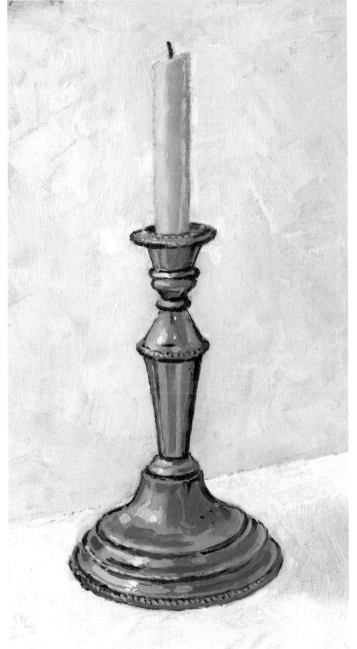

3 Now start to put in the larger areas of light and shade around the candlestick using your main colour in various tones. This is where the candle needs to be made to look more convincing, with light and shade in a waxy colour and with the black wick at the top. You will probably have to lighten the background colours now, mostly with Titanium White added.

4 The final stage is where the object starts to come to life, with many small touches of colour and tone in exactly the right places. The very darkest can be almost black, and the lightest solid white. The background will also need working up a bit more too, so that it looks solid and interesting.

Still life with orange and lemon

So that you can tackle more advanced forms, the next project is a small bowl with an orange in it and a lemon lying next to it.

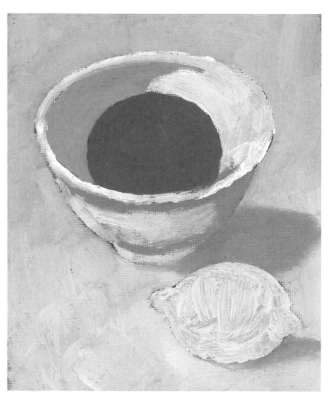

1 Again, the drawing comes first, on a prepared ground.

2 (*above right*) Put in the main colours, this time rather more intense, with Cadmium Yellow Light for the bright yellow of the lemon and Cadmium Orange for the strong hue of the orange. Put in the main shadow inside and outside the bowl and the cast shadow on the tabletop using mixes of French Ultramarine and Burnt Umber with Titanium White and a little Naples Yellow. The background can be a fairly neutral colour and tone.

3 (*right*) Next add some lighter and darker colour to the lemon and orange to make their forms rounded and put in the pattern on the bowl. Sharply define the edges of the bowl and strengthen the highlighted areas and the shadow at its darkest using mixes of French Ultramarine and Titanium White.

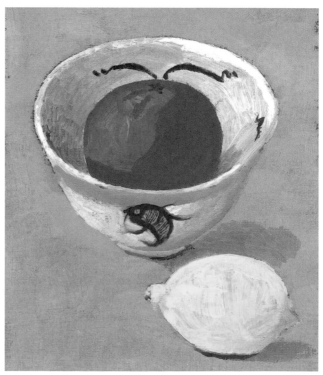

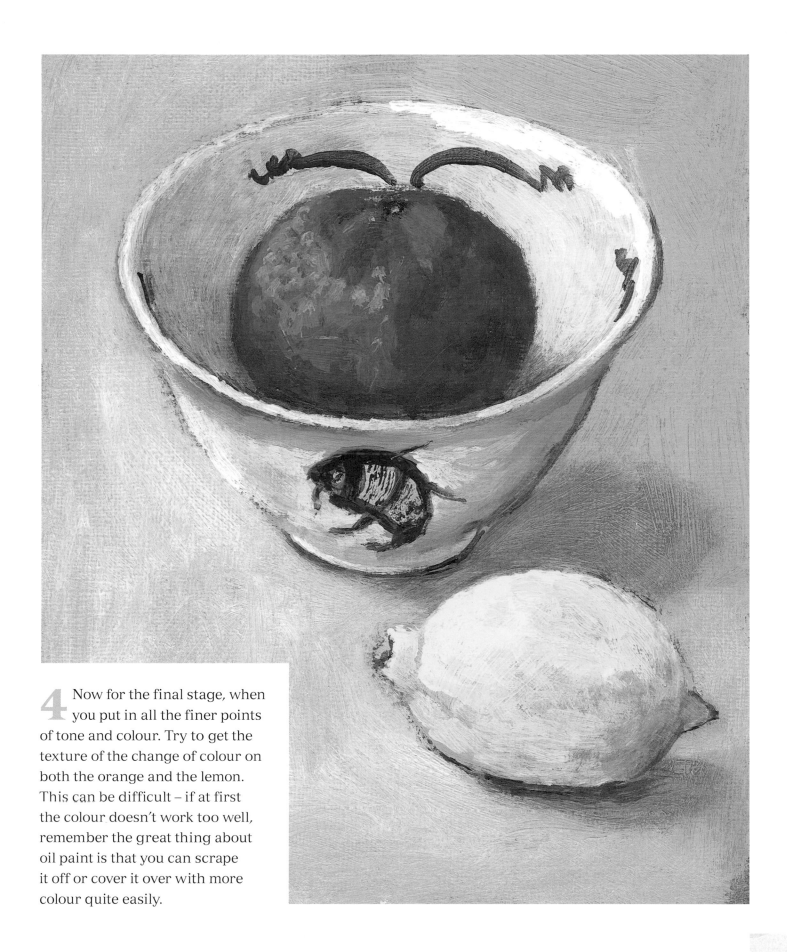

4 Now for the final stage, when you put in all the finer points of tone and colour. Try to get the texture of the change of colour on both the orange and the lemon. This can be difficult – if at first the colour doesn't work too well, remember the great thing about oil paint is that you can scrape it off or cover it over with more colour quite easily.

A big still life project

Now comes the moment when you really get going on a serious still life painting composed of six objects, some of which are complex. This is where you test your skills to the limit. The objects are a glass jar, a large, heavy ceramic pot, a green glass bottle, a glass jar with marbles inside it, a woven basket and a big sea shell. They are all well lit and placed on a deep green tabletop.

1 First, draw your subjects on your prepared canvas in outline paint, as you are now accustomed to doing. Take care to make the sides of the upright objects accurately in line with one another.

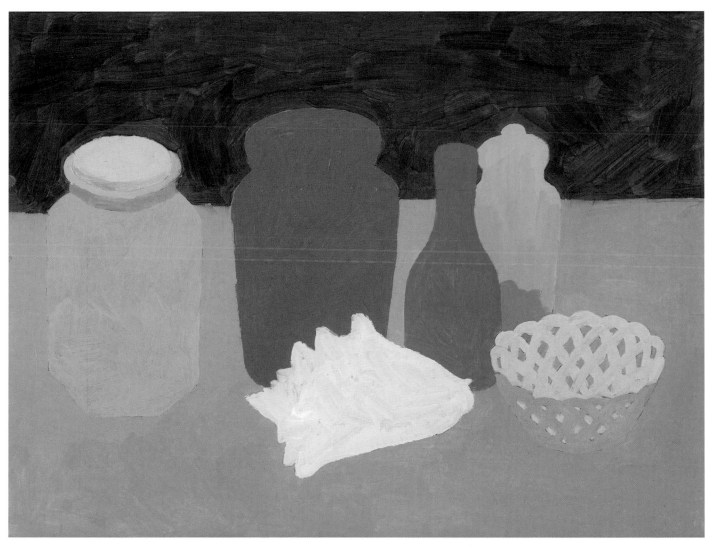

2 Now block in all the main colours quite simply, the glass jars with the colour of the background showing to a certain extent and the other objects in the simplest version of the colour that looks right to you. The background in the distance is quite dark, while the tabletop looks a lot lighter.

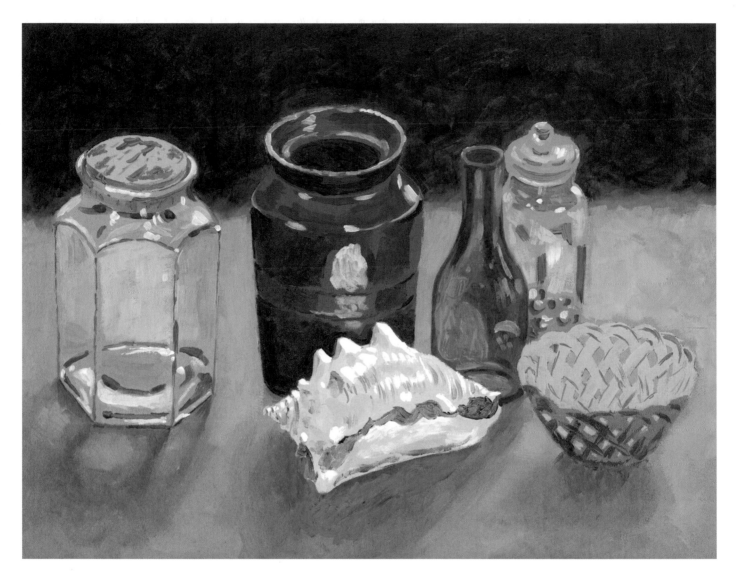

3 Next you need to draw on your creativity as you start to put in all the different tonal ranges you can in order to give the objects their characteristic qualities. Spend a lot of time just looking at the objects to see exactly what colour is needed and how big or small each shape is. Some of your marks will be rather splodgy, while others will be sharp and fine. Don't try to put in every little detail, as sometimes this reduces the power of the ensemble. And don't forget that you are working over the whole area of the painting, and the background is just as important as the objects on the table.

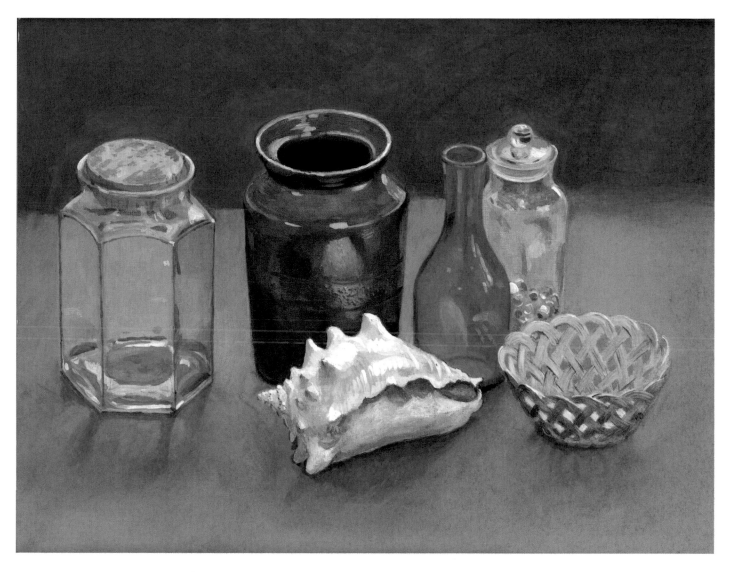

4 Lastly, take your time to refine anything that looks too clumsy and soften up the way colours relate to one another – very carefully graded patches of colour in between the extremes of tone often give a more convincing look to the whole. Some details you can ignore, while others must be just right. The way to test this is to stand back from the picture and look long and carefully at how it strikes the eye.

A small garden view

This small garden landscape painting is the first shown in this section because it is more controllable than a large open landscape. A view out of a window on to a garden, it has a strictly limited perspective. This allows you to start without too many problems, getting to grips with landscape in a measured way. All that can be seen are a few bushes, part of a tree, a lawn, a potted plant and a vase on a windowsill. The idea is that you can practise painting a landscape with a view neatly framed for you and without having to be concerned with too much depth from foreground to background.

1 The stages are as usual, starting with a sketched outline that sets the position of each object in the frame. This is the point at which you decide exactly how much of the scene you are going to paint and what you will leave out. Be aware of the position of everything and how the features in the scene relate to one another.

2 Next block in the main colours in each area, but don't worry about any detail. At this stage you are merely indicating the balance of colours and shapes. Notice how the light falls and which parts of the picture are dark and which lighter. Try to get the balance of the colours used, being clear about those that appear strongest and those that are softer in tone. At this point, the textural values

are not so important, but bear in mind that they will be in the next stage. Make sure that all the main areas are covered in a layer of paint, even if at some of the edges the undercoat shows through. I decided at this stage that the bench was too fussy for an early effort at landscape, so I just painted it out. It is quite common for landscape painters to remove or change the position of objects in the landscape for better effect.

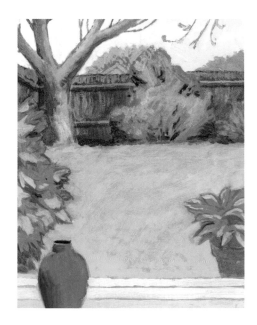

3 Once that is done, put in the areas of shadow and light to give some idea of a three-dimensional scene. This is where you have to decide what texture you are going to show in the vegetation, remembering that the parts closest to you will have a stronger or more obvious texture than the parts further away. This is not just a question of the colour strength, though that can come into it. Again, remember the rule of optics, which dictates that warmer colours seem to advance towards us while cooler colours recede. Decide exactly which parts of your painting you might want to simplify and which parts you want to make less obvious.

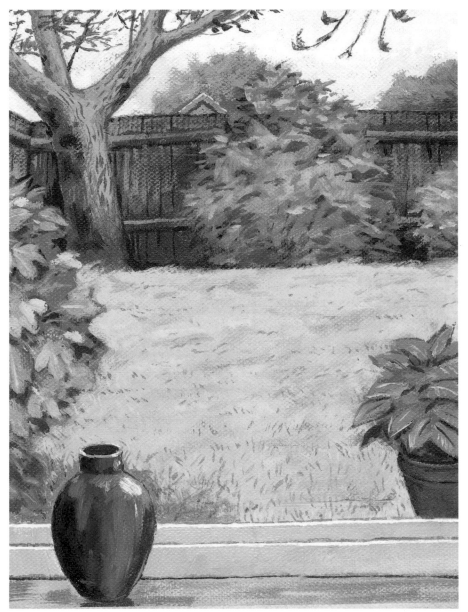

4 Lastly, put in all the necessary details and textures, making sure that the parts closer to your viewpoint are given stronger texture and warmer colour.

Painting a tree

The next step on your way to painting a whole landscape is to try a big tree in order to familiarize yourself with the size and grandeur of larger areas of vegetation. I walked to a park near my home where there are a lot of large trees; whether you live in town or the country you should easily be able to find a similar scene. I took a photograph, including a human figure walking across the grass to give you an accurate idea of the scale of the tree.

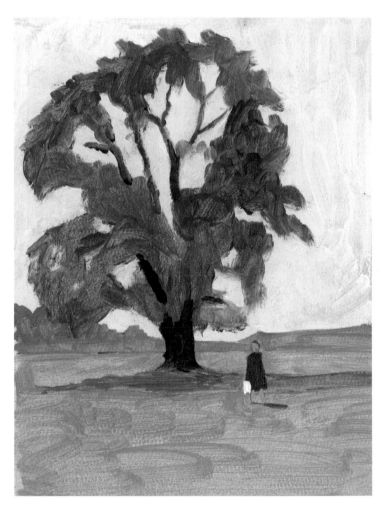

1 First comes the drawing on a prepared surface as before, blocking in the main outline shape of the tree and the environs immediately behind it. Block in the large shadow stretching below it, and include the main branches that you can see through the gaps in the foliage. Don't try to describe the bits where the gaps are partly covered in thin layers of leaves – just show them as gaps wherever you can see the branches.

2 Next block in the sky colour, which as you can see was rather cloudy, though bright. I used a mix of Titanium White with a little French Ultramarine, keeping the whole sky quite light in contrast to the tree. The tree was blocked in with mainly Permanent Sap Green and Burnt Umber and for the rest of the scene I laid down the same green, reduced a little with either Naples Yellow or Titanium White, or a mix of both. I then added a little Cadmium Yellow to brighten up the green in the foreground.

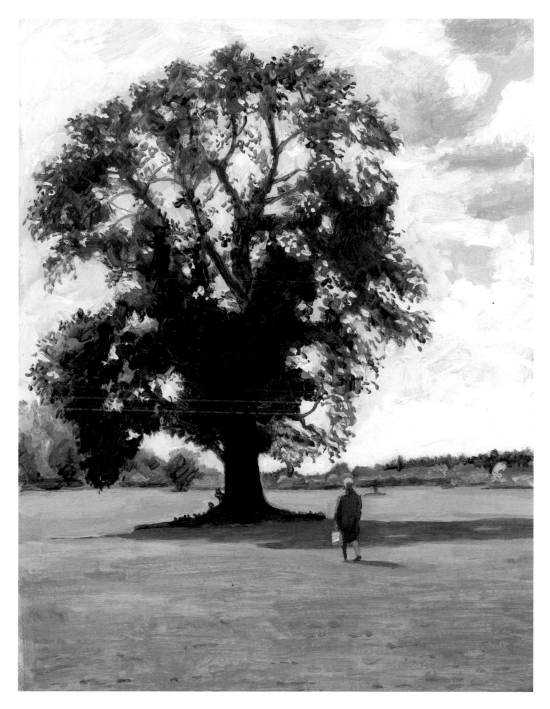

3 To finish the sky, work over it to give the effect of clouds, either darkening it with grey (Burnt Umber and French Ultramarine mixed with Titanium White) or adding a little Cerulean Blue and Dioxazine Purple mixed with white for areas of sky showing through the clouds. Then turn your attention to the tree, defining it with various versions of green, blue and brown. You could even put a little Dioxazine Purple in with the greens to darken them in an interesting way.

The background scene needs some yellow of different kinds to lighten up the grass where the sun is shining on it, as do the treetops in the background, which look much lighter than the tree. You don't have to draw every leaf – a general effect of uneven leaf masses is the way to tackle it, but be a bit more deliberate with the outer edges of the tree.

Skies: practice

In any landscape the sky always has a big part to play, even if only as background. Many landscape painters have had great fun working up their cloudscapes to add some emotional content to what might otherwise be rather tame landscapes.

Storm clouds

The most obvious use of the sky is in storm clouds, making any landscape beneath look more dramatic against the dark sky.

Heavy cumulus clouds

Large, rolling cumulus clouds can give a very active effect, as they appear to move across the upper part of your picture.

Cirrocumulus clouds

A summer sky with its blue vault touched with a few cirrus-type clouds is a good way to bring light and peace to a scene.

Small altocumulus clouds

On a day of sunlight and warmth, distant haze and altocumulus clouds help to increase the feeling of delight in the day.

Cirrus clouds

A sunny day may have streams of cirrus clouds across the sky with a warm-coloured haze in the far distance to give the feel of summer.

Evening sky

When the sun starts to go down and the clouds are bright with a warm glow, the scene can look very peaceful.

Mountain landscape

The main difference between a mountain landscape and hilly or lowland areas is that seen from a distance, mountains look rather bluer than most other backgrounds. This is partly because of the distance, and therefore the amount of atmospheric haze that intervenes, and partly because mist or clouds tend to gather around them.

1 As in our previous paintings, the main shapes are drawn with a brush on a prepared surface, but this time, because it is to be a cool-coloured picture, I have used a grey-green tone mixed from Viridian, Permanent Sap Green and Titanium White and drawn the outlines in Burnt Umber.

2 In order to get the right darkness of the overclouded sky I painted it in a blue-grey colour of French Ultramarine, Burnt Umber and Titanium White. Then I put in the shape of the most mountainous area with Viridian, French Ultramarine and Titanium White, making it just a little darker in tone than the sky. For the next layer of hills I used a greeny grey with a bit of yellow in it, mixed from Sap Green, French Ultramarine and Naples Yellow, in exactly the same tone as the mountains. Then the foreground was painted with layers of Sap Green, Sap Green mixed with Cadmium Yellow Light and a touch of white, Burnt Sienna and Sap Green and Burnt Sienna and Naples Yellow. All the trees were painted in Sap Green.

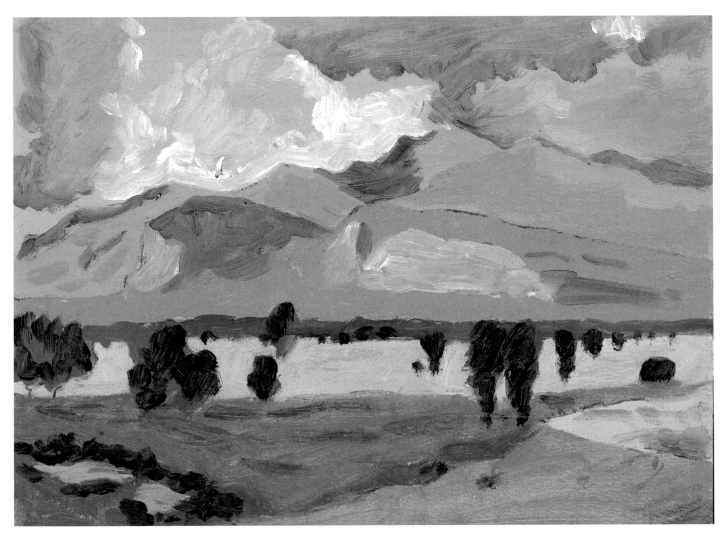

3 In the next stage I had to mix up colours that I had already used but in slightly different combinations to make them bluer, browner or paler. The clouds needed definition and the different peaks of the mountain range had to be indicated to increase the effect of their bulk. In the foreground, the trees needed differentiating so that they appeared to be either closer or further away. Some more detail was also required in the foreground to increase the texture.

4 *(Overleaf)* In the final stage all the details could be put in, with softening of the cloudscape and detailing of the rocky parts of the mountains. Then I worked up the foreground to make it look closer and more definite, while the mid ground of the trees and plain could be carefully transformed with subtle details to give the effect of land stretching back from our view.

Seascape

Here I have started a landscape that is all sea and beach, where you won't have the task of dealing with vegetation if you want to have a go at it yourself. I divided the picture horizontally into grey-blue sky, slightly bluer sea and two stages of sandy and pebbled beach. I used pencil to make the initial drawing as it was the fastest way of getting it down in a landscape with rapidly changing weather.

1 The sky is Titanium White with a touch of French Ultramarine mixed with Burnt Sienna; the sea is again Ultramarine, but with a dash of Naples Yellow, some Titanium White and a touch of Viridian. For the beach I used mainly Burnt Sienna with some Naples Yellow; I added a touch of Burnt Umber in the low-light areas and Dioxazine Purple in the brighter areas as it gives a zing to the shadows. The pools of still seawater are in the same colours as the sky, but with much more Titanium White added; they reflect the sky better than the restless sea does. The foreground, which is the pebble part of the beach, is painted mainly in Naples Yellow at this stage.

2 *(opposite page, top)* Now the structure of the picture needed showing more clearly, so I strengthened the sea with some Cerulean Blue along the horizon. I also added darker marks on the sandy part of the shore to show the difference between the wetter and drier parts. Putting in the old, rotten wooden posts of the breakwaters and their reflections gave more structure. I lightened the brightest areas of the pools and marked in the white splash of gulls flying past or looking for food on the sands. The foreground of pebbles needed some texture, so I put in darker and lighter marks to suggest this.

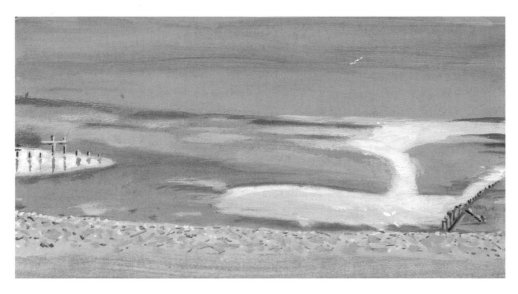

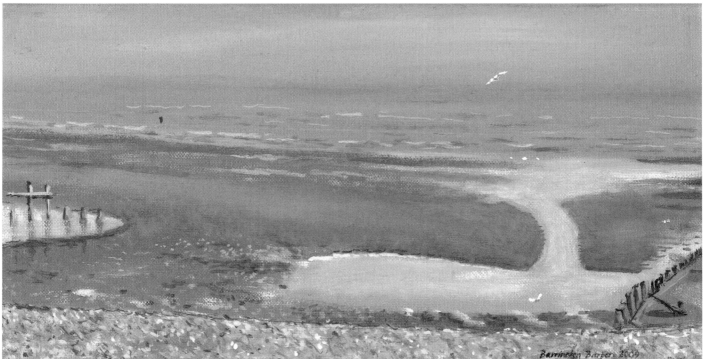

3 In the last stage, I worked on creating the illusion of depth and space. I was faced with many changes of light, as is so often the case when painting outdoors. I found it necessary to grey over a lot of the sky area and soften the effect of the horizon line, which had almost disappeared. I then carefully worked over the beach area to increase some of the details and strengthen the textures. The white dabs of paint were sufficient to show where the gulls were on the beach and I added some darker marks to show the waves on the sea. Greyish strokes gave the effect of the foam of the waves breaking in the shallow water. Some stipples of light grey helped to give the effect of wet indentations in the sand and sharper marks for the wooden posts made them stand out against the soft colours and pebbles on the nearer part of the beach.

Before I decided my painting was finished, I stood back to see if any more small touches were required. It's important not to sacrifice the overall effect by overdoing tiny details, and the painting had needed just enough to make the depth and open space of the beach scene look convincing.

Building as landscape

I decided to paint a landscape dominated by a view of an 18th-century house with Jacobean outbuildings. I drew various views of the buildings first. Although I thought they were all interesting, I was intrigued by the view of the back of the house where the Jacobean parts adjoined the 18th-century main building. It looked like a more interesting challenge.

In dealing with a building like this, some sense of perspective is necessary; in these drawings I have shown other elements of built landscape in order to convey the importance of the proportions and angles of the structure. This is not difficult – you just need to observe carefully how some parts of the building disappear behind others, and how windows and other architectural features help to show your angle of view of the building. Just be sure that the main lines of the outer shape of the structures are clear and in proportion.

1 The main structure is made of red brick with a slate roof on the outbuilding and a bit of tiled roof showing at the right-hand edge. To get these colours I used Burnt Sienna for the red brick and a mix of French Ultramarine, Burnt Umber and Titanium White for the slates. For where the sun was shining strongly on the sides of the buildings, I used Naples Yellow with a touch of white. I painted the sky in French Ultramarine, Cerulean Blue and Titanium White, and used Permanent Sap Green for the vegetation at the base of the buildings and on some of the angles.

2 Next came the stage of putting in the textures of brick and other materials, showing the discolorations in the surface from the effects of time. Then I marked in the architectural shapes, such as the edges of windows and piping from the guttering. At this stage the details of the window structure could be well defined and some of the plants along the base marked more obviously. Some extra colour on the roof also helped with the feeling of real surfaces that have been exposed to the weather for many years.

3 In the final stage I had to make sure that the buildings looked as though they were solid, three-dimensional, heavy masses in space, so I worked on creating subtle shadows and marking crisp lines of brickwork and slates in the main structure. I found I had to adjust some of the shadows, softening or strengthening them here

and there. I defined foreground elements more clearly, while the sky and further parts of the building had to be made less defined. To do this, I waited until the undercolours were all dry and then laid a thin glaze of colour over the further parts of the buildings to push them back.

Urban landscape

The painting of an urban landscape is a little more difficult in practical terms because the space available to set up an easel and stand painting in the street is usually limited. Passersby are mainly very courteous and tend to be appreciative of the efforts of the artist, but ideally you should find a place where you won't cause any obstruction.

The next problem is to decide how much of the crowded scene you want to include. A view along the side of a street where you can see the far end is usually good because there is a natural limit to your space, so that's what I've chosen to depict. The light in this London street is interesting, because the buildings behind me are casting a shadow across the lower half of the street.

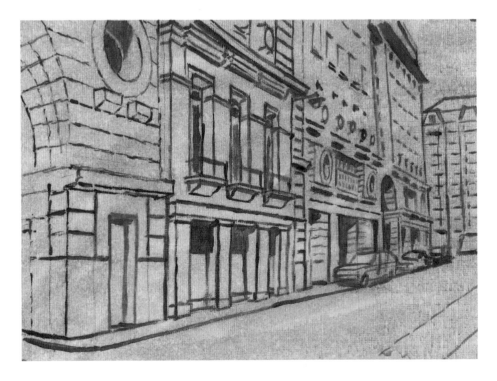

1 The first thing is to make sure that your perspective will work in the picture, so a bit of careful drawing and measuring will help here. As you can see from the adjoining perspective diagram, the vanishing point of the main lines of the perspective is not even on the picture, so a certain amount of guesswork is useful here. It won't matter if your perspective isn't entirely accurate as long as the feel of the space is captured well.

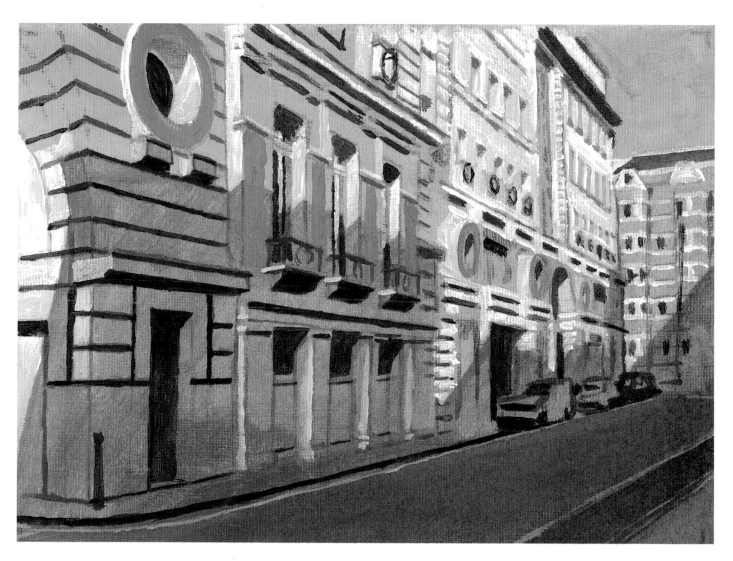

2 In this painting the buildings are partially in strong sunlight and partially obscured by shadows cast by the buildings on the opposite side of the road. This means that the lower half of the buildings looks much darker in tone and colour than the rest of the picture, so when you start blocking in, define the edge of the darker shadow as well as all the obvious changes of colour as I have done. All of the lower half of the scene will seem much darker than the rest, but don't put it in too heavily at first, because you will find it needs careful building up of all the changing surfaces within the darker shadow.

3 When all the main colour values are present, you now come to the part that requires much slow, careful defining of the detailed shapes, and the various subtle colour ranges within the overall context. The nearer parts of the buildings will be stronger in colour and more definite in the edges of the hard surfaces. Build up the darker parts gradually and try to get the contrast betwcen the light areas and the very darkest parts. The further the buildings are from the viewing position the less sharply defined the details need to be.

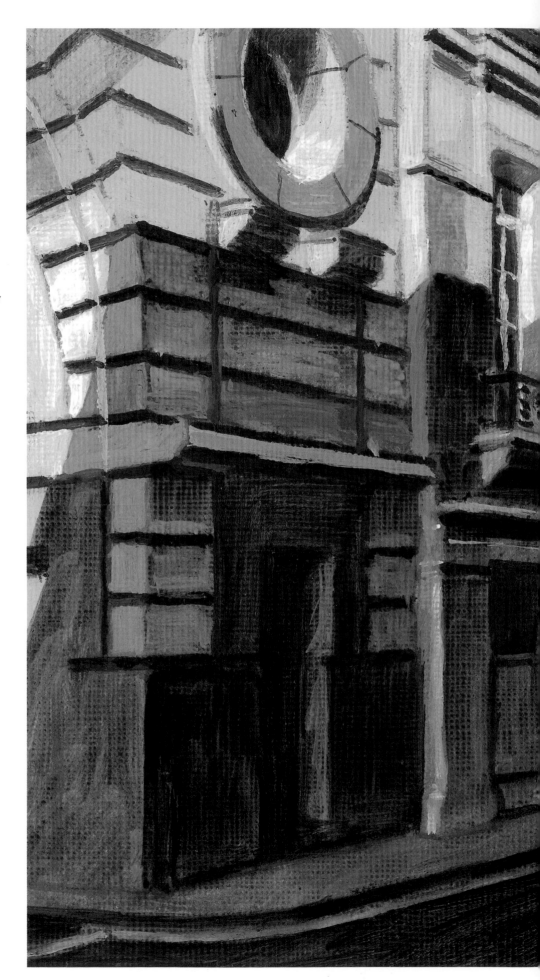

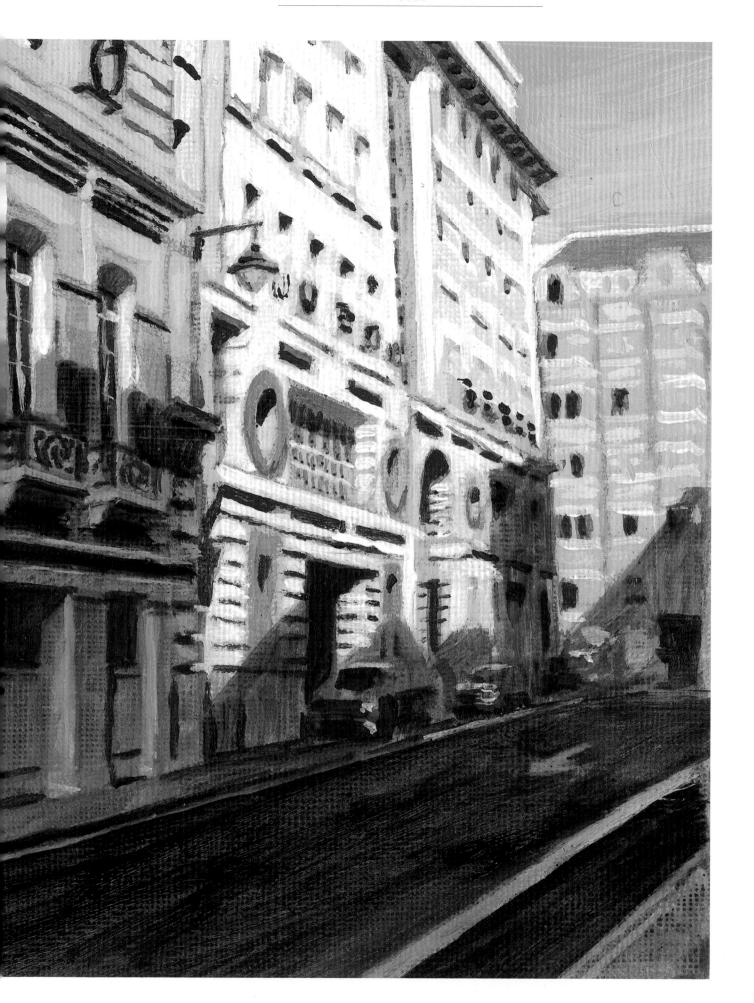

Portrait of a child

Most learning artists, having got to the point of painting the world around them, become keen to try a portrait. The most obvious aspect of this is painting the face, but as you will see there are a lot of other points to consider. A portrait may be a head, a half figure, or the complete full-length figure, all calling for various kinds of detailed attention from the artist.

This portrait of one of my grandchildren was made from a photograph I took of her playing in the garden.

1 I mapped the image out first very simply with a pencil, then sketched in an outline in Burnt Sienna on a paler ground of the same colour.

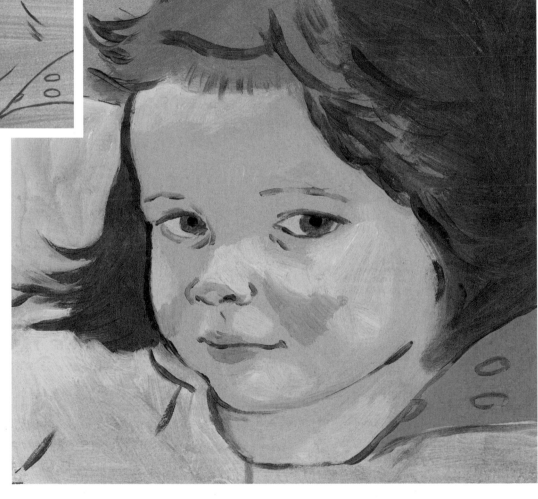

2 Next I blocked in the main colours of the face and the clothing and background that can be seen, using mostly Naples Yellow, Burnt Sienna and Titanium White, with a touch of Permanent Sap Green and French Ultramarine. On the face I used some Flesh Pink to warm up the skin tones, but I also applied a little Dioxazine Purple to give a cooler tone to the shadow. Flesh Pink also appears in the hood, while there's a little Cadmium Yellow Light in the greenish colour of the coat.

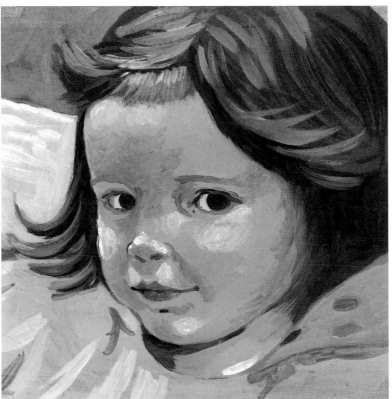

3 In the next stage I began to build the darker shadows on the face and hair and to define the eyes, nose and mouth more precisely – they needed to be drawn as carefully as possible to ensure the portrait looked convincing. I also put in the brighter lights on the face fairly freely. At the end of this stage you should be able to see the three-dimensional quality of the head and features.

4 Finally, I needed to balance out all the tones and colours to make the result look as though the subject was made of flesh and blood, with shining eyes, healthy hair and soft skin, with the colours and tones softly melting into one another so that none of the shapes look hard. At this stage the very darkest and very lightest touches of paint were important for defining the head.

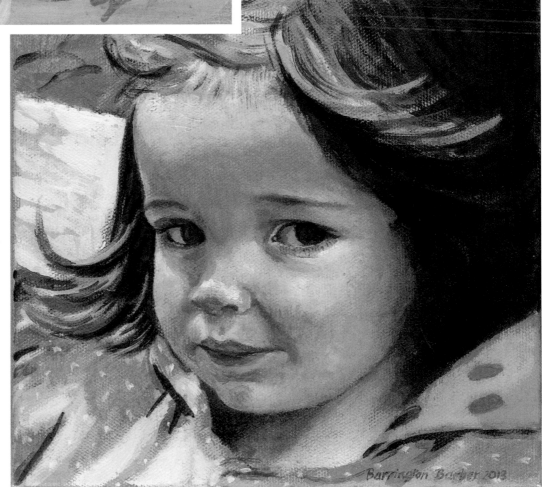

Portrait of a young man

There are many notable portraits of young men to be found among the works of Old Masters such as Bronzino, Botticelli, Leonardo da Vinci, Raphael and Rembrandt – these are often self-portraits done in their youth. Try painting the young man I show here so that you develop the confidence to tackle a model of your own choosing.

1 First make the outline drawing of this young man on a canvas prepared with a diluted Burnt Sienna ground. You may find it easier to use some pencil lines before you start drawing with the brush. The surface will have to be dry before you can start painting, but if you are using quick-drying alkyd oil paints this will take only 12–15 hours.

2 Next, block in the main local colouring, including the area of shadow on the face. This allows you to see the balance of colour and tone early on; if you get it right now, it makes the whole job quicker and easier. The Burnt Sienna ground makes a good basis for the main flesh colour; I used Naples Yellow and Titanium White mixed with Burnt Sienna for the lighter areas and a bit of Dioxazine Purple with Burnt Sienna for the darker parts. The green jacket is mostly Permanent Sap Green; the T-shirt and hair are French Ultramarine and Burnt Umber. The background colour is Naples Yellow and Burnt Umber with a touch of Titanium White.

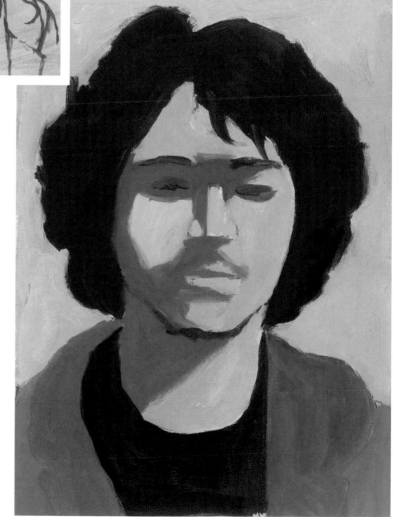

3 Next we have to make the dimensions of the head come to life by working up the tonal values and finer points of colour and shape. Here is where the mouth, nose and eyes need a lot of attention and the background, clothing and hair must be worked on to make the depth of focus more convincing. You will need to add quite a bit of colour on the facial features and make sure the shapes are right. By the time you reach the end of this stage, the portrait should already look like the subject, with all the main colour work in place.

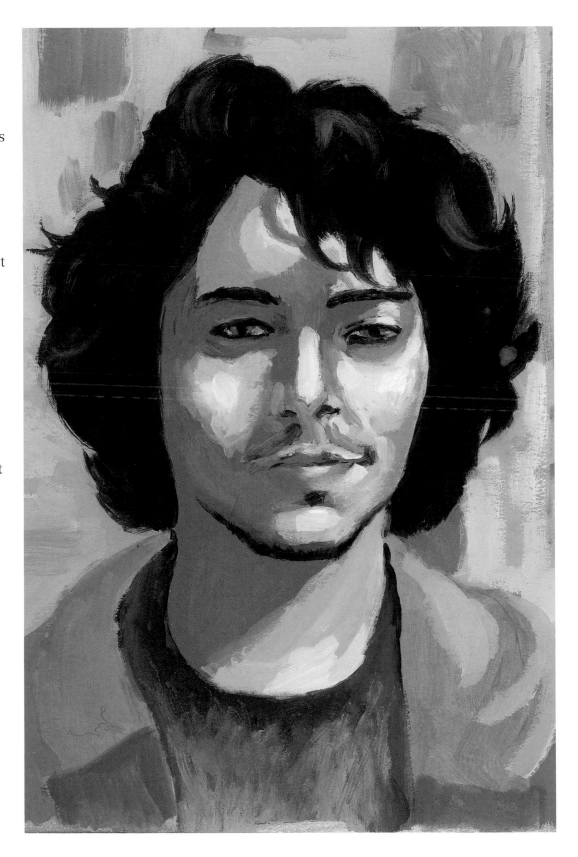

4 At the last stage I made a deliberate attempt to give the portrait added life by using colour more impressionistically, with specks and brushmarks of quite strong colours vying with one another to create a lively colour surface. This gave a sense of immediacy to the features and added a certain bounce and brilliance to the final portrait. Where this technique is helpful to the life-like qualities of the sitter it can be used very effectively, so it's worth practising. This young man has a very direct and forthright nature and a certain confidence, and I felt this method was well suited to his personality. He is an art student and his own painting is also very much like this.

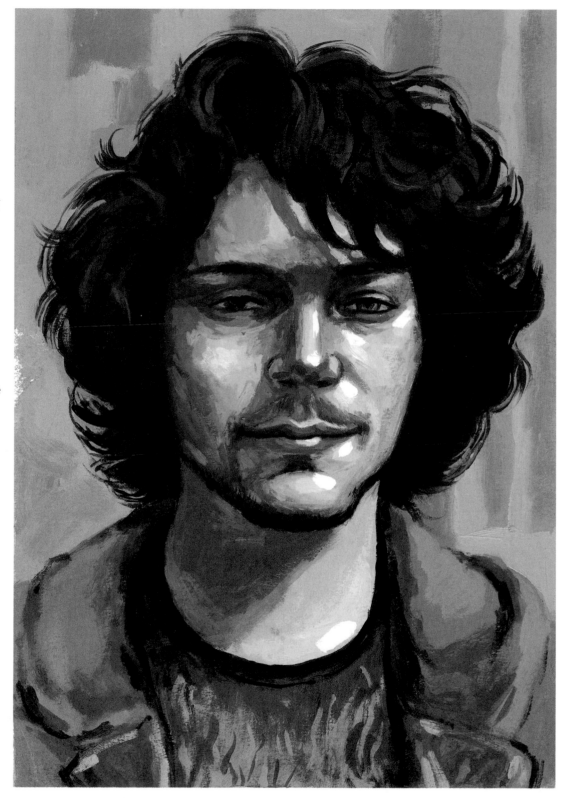

Seated figure portrait

This painting is of a young African woman wearing elaborate clothing. The drawing is not too difficult because the draped robes hide most of her body, so the shape is approximately a large triangle with the head perched on the top. The background, showing the walls of the room she's sitting in, is also fairly straightforward.

1 As usual, the first step is to draw with Burnt Sienna on to a weaker background of the same colour.

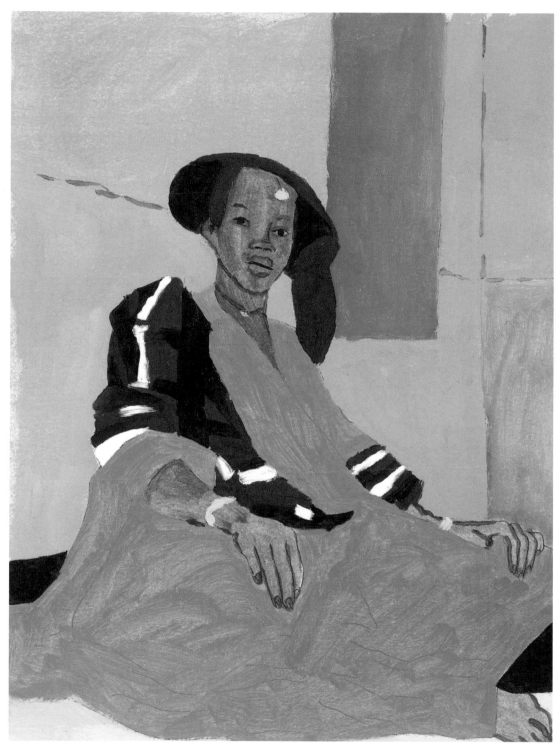

2 Next, block in the main colours, which are Permanent Sap Green mixed with a little Naples Yellow, Alizarin Crimson, Titanium White and Lamp Black. The background is made up of mixes of Naples Yellow, Burnt Umber, French Ultramarine, and Naples Yellow with Titanium White. Do this stage quite quickly to establish the balance of tone and colour in the picture.

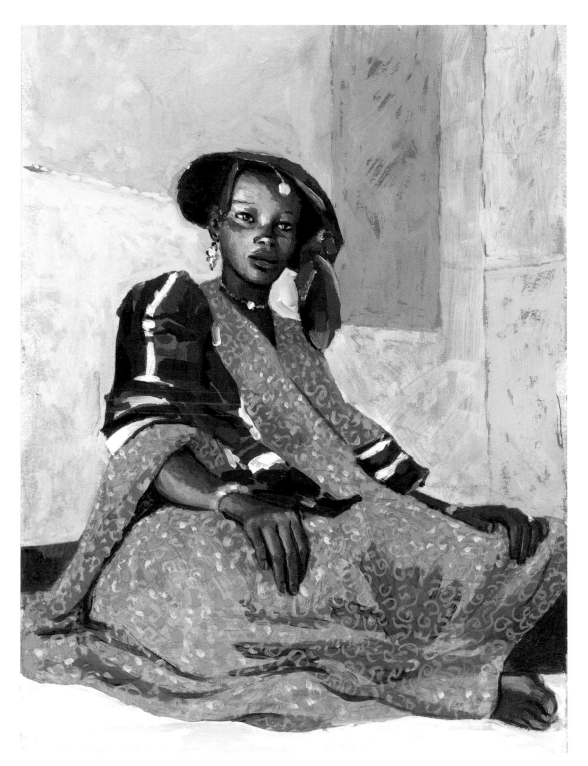

3 Drawing the pattern of the gilded dress is time-consuming, but if you want to get the right look it is worth doing well. You need to be careful when modelling the face and hands so that they look convincing. The walls can be worked over in various textures and colours to give a slightly worn look to the room. Deepen the colours on the dress where the shadows are, and work over the red, blue, black and white of the rest of the clothing to give it some substance. The most difficult parts of this painting are the pattern of the dress and the facial features, so be prepared to give them plenty of attention.

Double figure portrait

This is a figure painting of two men standing in a strong side light against a deep red and green background.

1 Drawing the two shapes shouldn't be too difficult, but the fall of the jacket and coat is important to the picture, so make sure you get this right at the preliminary drawing stage, briefly using a pencil first if it helps.

2 Next, block in the major colours. The strong red of the wall immediately behind the men is mainly Alizarin Crimson, with a bit of Dioxazine Purple to dull it down. The red jacket and tie of the man on the left are an equal mix of Alizarin Crimson and Scarlet Lake, while the rest of the clothing is largely a mix of Naples Yellow, Burnt Umber, French Ultramarine and Titanium White. Mark in the edges of the clothing at this stage and put in the dark shadows. The hair is white, with a little Ultramarine added.

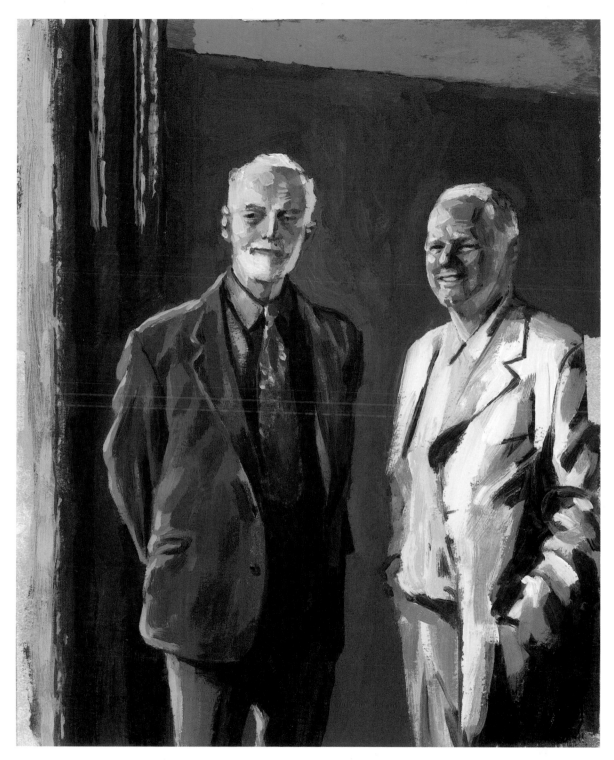

3 Don't try to show much detail as the light in this picture is very strong and comes from one side, creating rather harsh shadows and bright highlights. Keep the brushmarks obvious rather than trying to smooth them out, so that the resulting picture has a strong, slightly sketchy look to it. You need to put in the smaller, lighter edges to the red jacket and indicate some sort of pattern on the tie, but make the brushstrokes loose to give the picture a bit of vibrancy which the composed stance of the figures lacks. To finish, lighten the background colour close to the figures and give some idea of the decorative structure of the door frame behind the men.

Different portrait techniques

It isn't always necessary to have an all-over detailed piece of work to achieve a successful painting. Sometimes it's better to keep the painting broad-brushed or more graphic in its method to produce a good portrait.

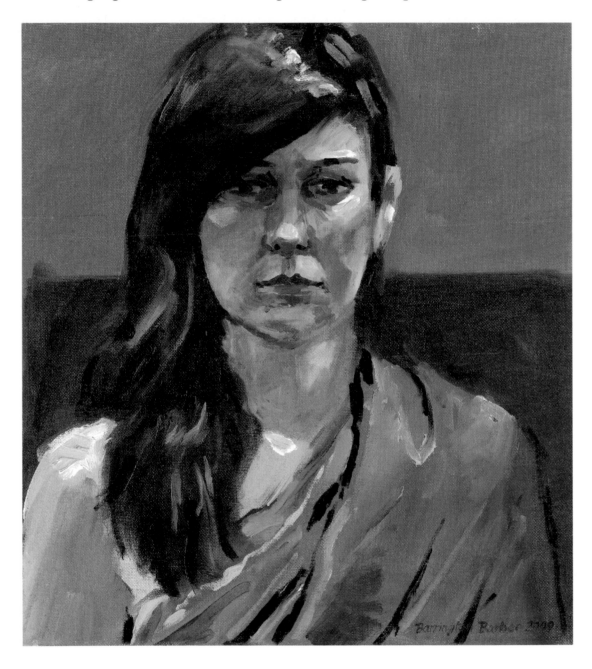

Sangeeta

Here a portrait of a young singer has been left with all the brushmarks showing so that the energy of the actual painting technique is evident.

I made no attempt to blend in any of the colours, but it still seems to work.

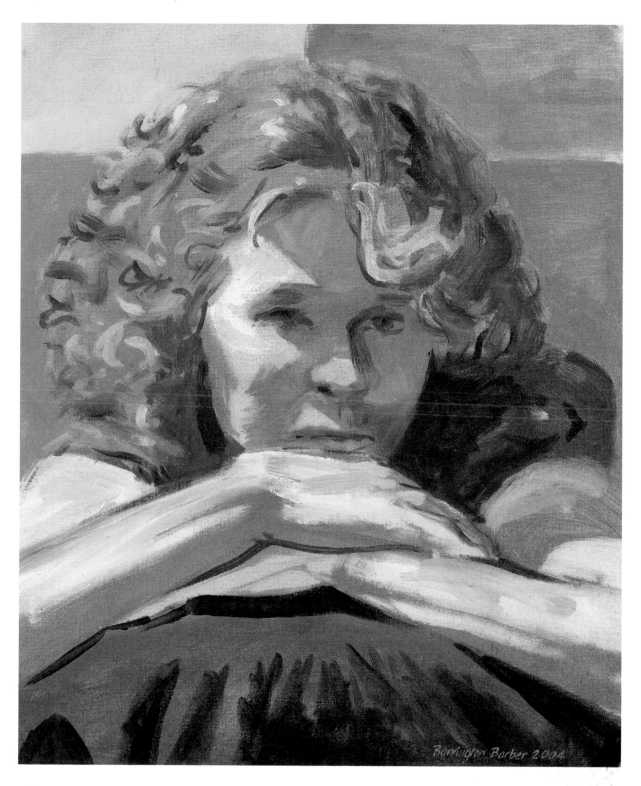

Pensive woman

This portrait of a woman leaning pensively on her hands was done very quickly with quite thin wet paint, so that there was a blending of colours but a limited attempt to work in any detail. This was partly because there was not much time to do that, but also because it works as an effective technique in painting. The amount of time you spend on a painting isn't necessarily related to its success.

Self-portrait

The benefit of drawing your own portrait is that you can take all the time you like. Use a large mirror that you can get relatively close to, because the distance you are from the mirror is doubled when you see the image. Good lighting is essential and if you want to paint a more profile view you will also need two angled mirrors, such as you find on a dressing table.

Take exact note of how you have positioned your head so that you can come back to the same pose each time you look up. The best way is to move your head as little as possible while you are painting, and if you can arrange your pose so that you only have to move your eyes, so much the better.

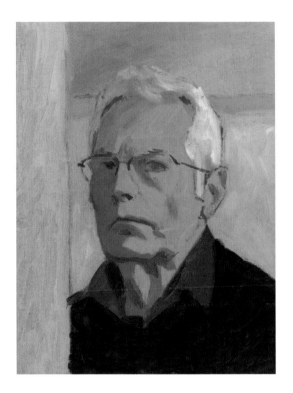

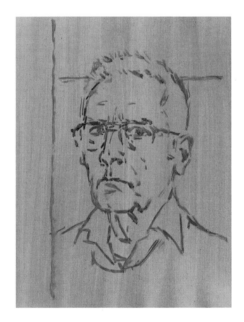

1 Starting with a canvas prepared with a Burnt Sienna ground, I began to draw my portrait. This stage is when you settle the angle of view and put in outlines of the whole head and all the features. Include any obvious background, but don't be too detailed about this – the main point is the head. As you can see in my drawing, I have put in the edge of my canvas and a suggestion of the ceiling and wall behind me. Keep correcting your work until you are satisfied that you have a good likeness.

2 Now block in the main areas of colour and tone, keeping them as simple but accurate as you can. Here I put in a background of a greenish-grey, with the canvas edge in a warmer tone. I then blocked in the main flesh colour, which is a warm browny-pink colour from Burnt Sienna, Naples Yellow and Titanium White. I put in the shadows on the face very simply, using the same colours but with less white, and added some tone on the hair.

To take it to the next stage I further darkened the areas around the eyes, nostrils and mouth, and the shadows under the chin and near the hairline. At this stage your own painting should begin to look a bit like you, but still very simply done.

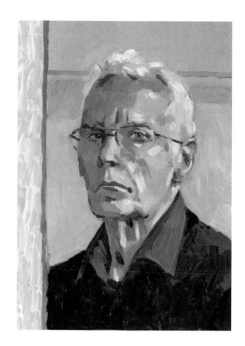

3 Next I worked on all the subtle colour variations on the surface of the skin until it began to resemble the colour and tonal value of the face in the mirror and the modelling of the features was clear. The highlights were put in next to get some idea of the contrast between the darker parts and the brightest lit. When you have finished this stage you should have a good likeness of your head but still rather impressionistic, although all the form should be obvious.

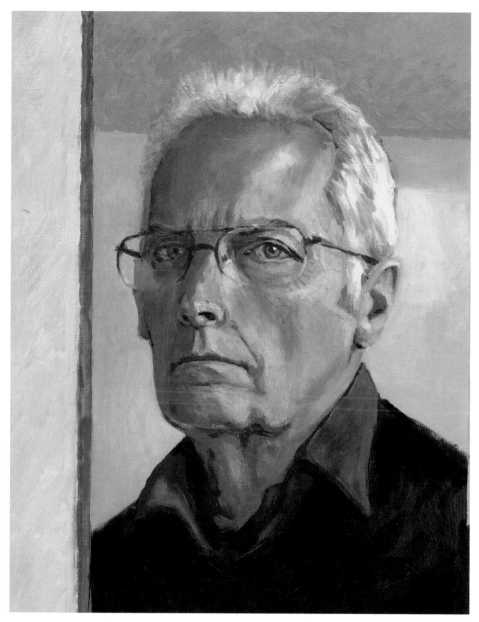

4 The last stage was where I really had to concentrate hard. Once the paint had dried, I slowly and carefully added variations of the colours until the rougher marks began to merge into each other and started to resemble real human flesh. Don't forget to put in the background work as you go along or else the tone and colour will become unbalanced. Everything must start to look much more realistic now, and this means emphasizing some parts and toning down others. As always, keep stepping back from the canvas to see the work at more of a distance, so that it's easier to check which colours to use. Sometimes you will only be putting tiny streaks of paint on the canvas in order to get the right quality of tone and colour. Don't give up until you cannot see any more work that needs to be done.

Two up a tree

For the last painting in this section I have used a pair of figures, and this time they are my young grandchildren up in a pear tree in our garden. They were quite pleased with the idea of being in a picture but even so they were unlikely to stay still for very long, so photography was called for to fix their pose. In this composition the younger child, the girl, was closer to my viewpoint, and the boy, although older and bigger, was further away and therefore looked smaller.

Unless you are attending a life class, where all the models are professional and can remain still for some time, you will mainly have to use photographic reference as I have done to get all the information that you need.

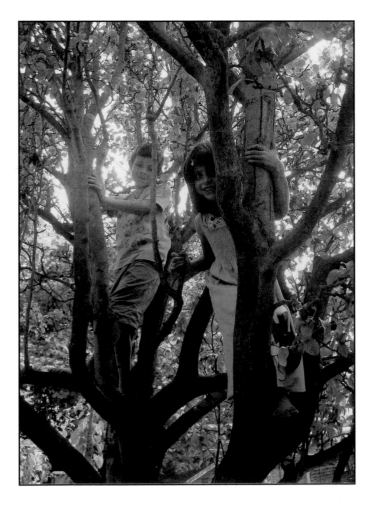

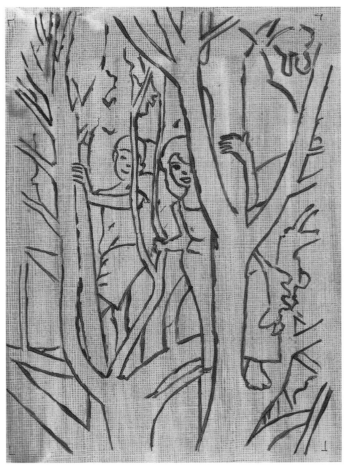

1 On a prepared canvas, I drew in the main outlines of the branches and the two figures, which were partly hidden by the larger branches. Partially obscured figures frequently occur in figure compositions, adding to the dynamic of the scene.

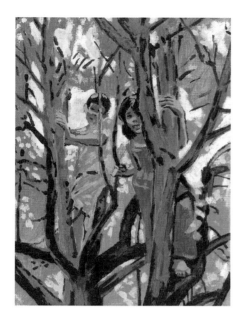

2 Next I blocked in the colour, which here was mostly the dark greenish-brown of the branches and the mass of foliage all across the background. The two children were both wearing blueish clothes and these were blocked in as well as their warm skin tones.

3 After this came the task of differentiating the light and dark foliage and the slashes of sky showing through the leaves. The texture of the larger branches was important, too, because it indicated whether a branch was nearer to or further away from the viewpoint. I kept the brushmarks fairly broad, so that the simple shapes of the figures could be seen against the varying texture of the leaves.

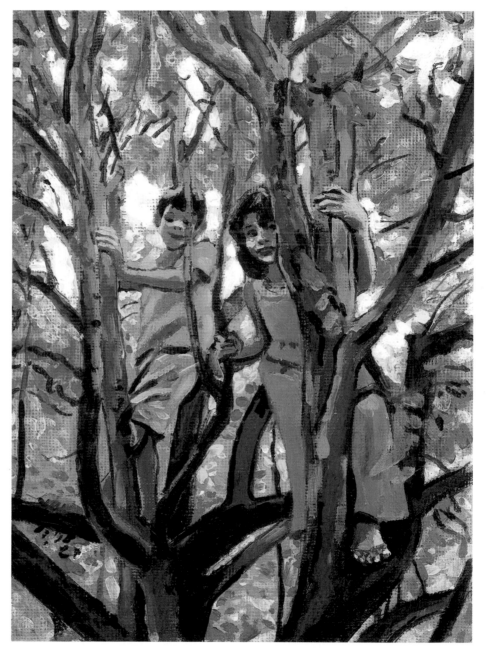

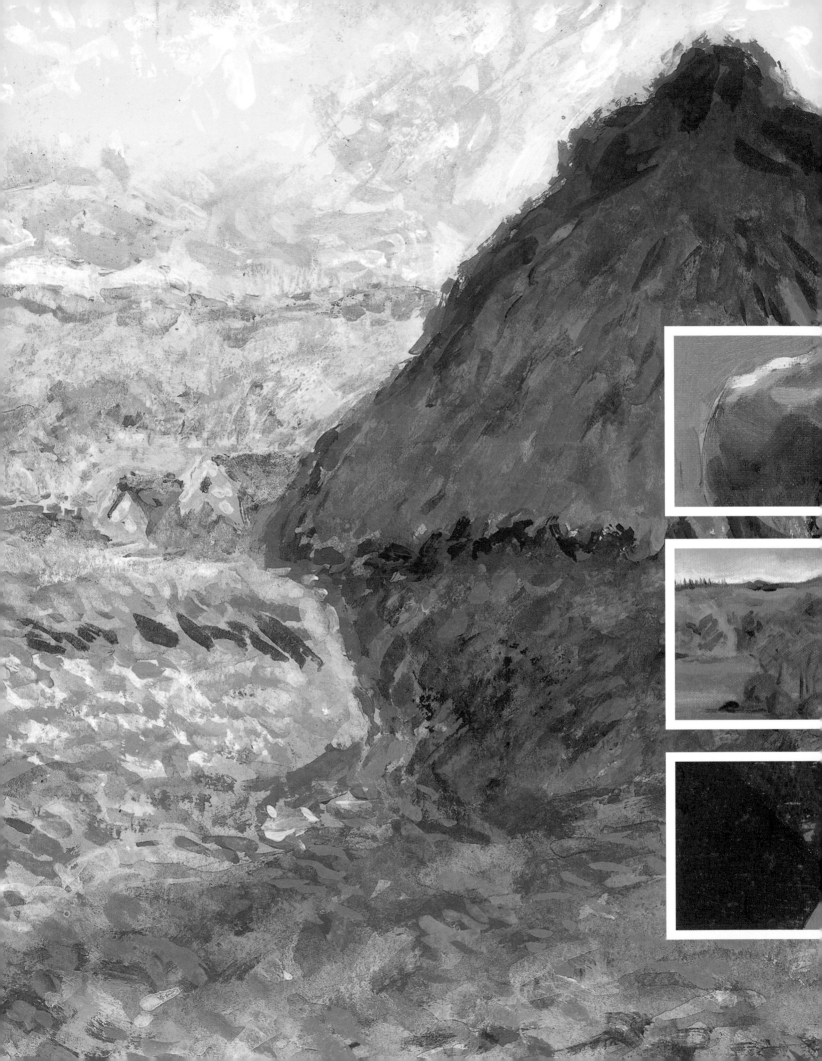

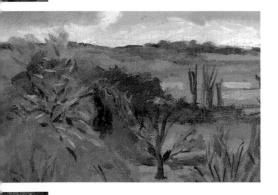

4 Composition, Technique & Style

When you are painting, there are many things to take into account – composition, technique and different ways of handling paint being the most obvious. The examples in this final section are fairly diverse in terms of composition and technique, but all except for the last two, which are abstracts, are in a naturalistic style.

All painters evolve their own method and after a while you will naturally start to develop a style of your own. Don't try to 'get a style' – it will happen almost spontaneously. Just experiment until you feel you are painting in a way that brings you satisfaction and gives some interesting qualities to your work. Keep looking at other painters' work, especially if there are artists living near you who are prepared to discuss their paintings with you. You can either adapt the style of other painters or just work in your own method – both ways will give you insight.

Don't be discouraged if you feel that other works are much better than your own. You may not be the best judge of how good your work is immediately. Don't destroy your attempts – keep them until you can view them with a certain detachment. Then you will be able to tell what to keep and what to throw out or overpaint. Many great works of art have been overpainted, so you will be in good company!

Lastly, enjoy yourself on this journey into the world of painting. Try out as many methods as you can and learn from your mistakes so you can gradually improve your technique. I find painting now as much fun as I ever did, and I've been doing it a very long time! Don't worry about your rate of work; some painters take ages to complete a painting and others take just one sitting. Keep painting and enjoying the activity. You never know, you might produce a world masterpiece one day, but the enjoyment is the best part of it.

Watercolour paintings

The piece **on the right** is taken from George Price Boyce's *Streatley Mill at Sunset*, painted in 1859. The method is fairly clean-cut, with areas of colour put on simply but effectively to look like the scene in front of the artist. He has taken the trouble to paint the foliage against the sky in a fairly defined way, flicking on tiny patches of green. The buildings are built up simply, with one or two layers of colour, and it is not too difficult to see how

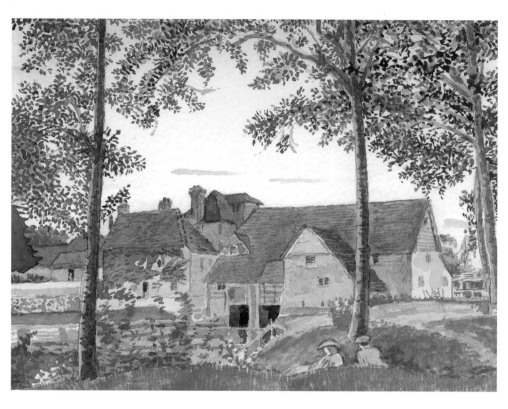

the colours were mixed. The tone is important and the colours are kept low-key on the buildings, which makes the sky look brighter and the dark-toned leaves stand out against it. The low-key colours also help to make the light look cooler. This is the sort of painting most people could achieve, given sufficient time and good weather.

The second watercolour, **on the left**, is different in that the artist has used his colour range very dramatically. You might succeed at this if you are competent enough, but it is a difficult effect to pull off if you are relatively inexperienced. However, that is the fun of watercolour – if it works, it is very effective and, if it does not, you get to do better next time, noting what went wrong before. This is *The Blue Night, Venice* (1897) by Arthur Melville, a painter who specialized in getting the greatest contrast in his colour values. The dark blue Venetian sky is produced by laying down several coats of deep blue one after another, waiting for each coat to dry. It builds up a colour of great intensity that really sets the artist's work apart from most painters working

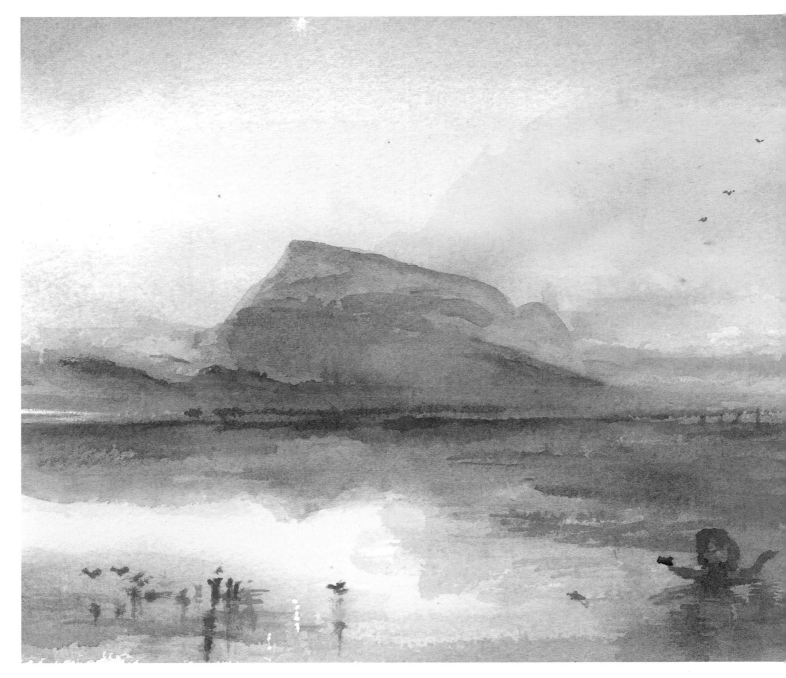

in this medium at this time. Detail is sacrificed for the drama of the colour contrast, which seems to work very well. Of course, it is not easy to work at night as all the colours look very different in low-level light.

The third example, **above**, is *The Blue Rigi* (1842) by that master of atmosphere, J.M.W. Turner. This artist had the ability to lay washes of colour fluently and very skilfully across the paper, without making the result look mechanically perfect. He seems to have worked on wet paper for this picture and allowed the colour to flood across it to great effect. The little areas of detail here and there help to make the larger areas of colour look more embracing. Turner's skill in leaving much out of the picture, but putting in enough to give it conviction, was masterful. He is very well worth studying for his brilliant technique.

Gouache paintings

This gouache miniature, known as *Young Gujarat Lady* from the Mughal School of artists in early 18th-century India, is a good example of the advantages of the medium. Gouache lends itself to most of the same techniques as watercolour, but because it can be painted over repeatedly and with great precision in opaque colour, it has great possibilities for miniature studies. This portrait of a young woman holding a flower is typical in that the painter showed every detail of the clothing with as much precision as he could muster. The background has been painted like a watercolour wash, but the precise elements of the figure and costume are rendered in strong opaque colours.

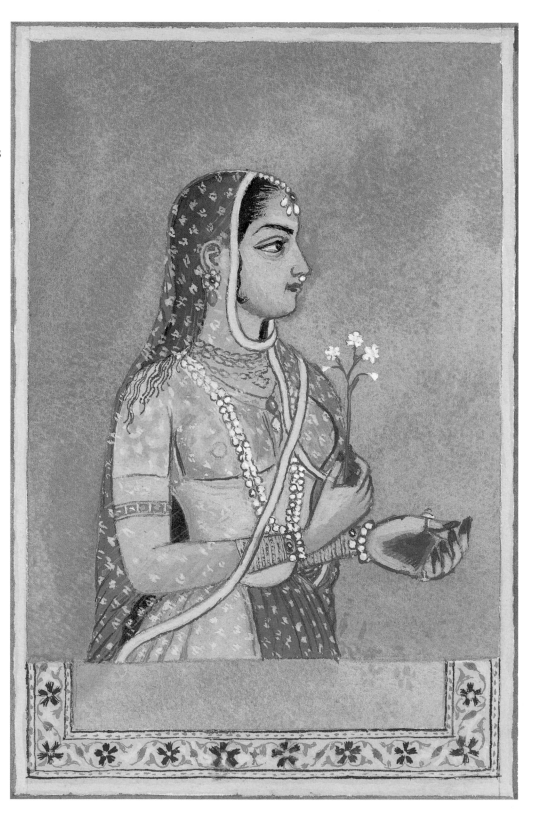

The second gouache painting, of a pilot in an antique biplane, is rather graphic in style and I've painted it in strong colours, mostly opaque. As it is easy to paint over earlier layers, you can work quite dramatically in terms of contrast. Any graphic picture is best painted in this medium, and that is why it is used so frequently by artists producing illustrative work.

Acrylic paintings

Here I have made fairly loose copies in acrylics of well-known paintings that were originally done in oils.

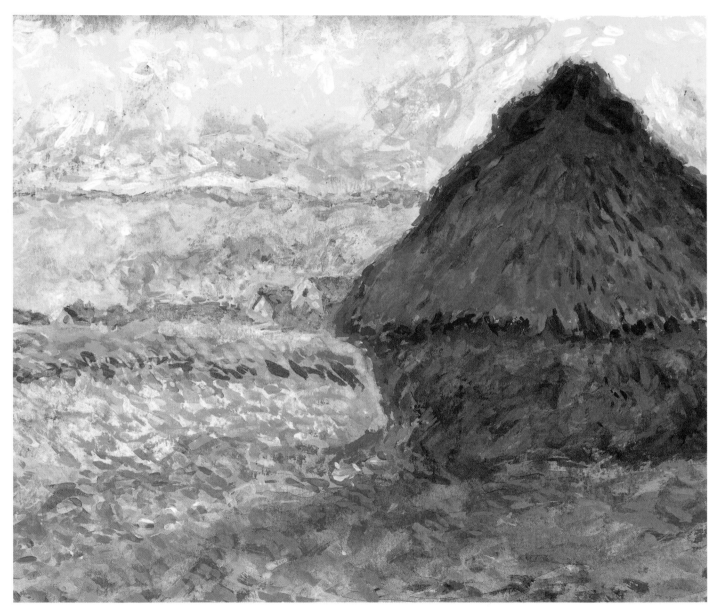

The first is *Haystack, Sunset,* painted in 1891 by Impressionist artist Claude Monet, showing how you can, without too much difficulty, produce a work that has most of the qualities of an oil painting, but using a simpler medium. The oil painting will have a greater richness of colour, but apart from that it is quite easy to get all the other effects with acrylic. I've used Monet for my first example, because his handling of paint is so typical of the way in which oil paints can be used and it is interesting to see if his style can be more or less replicated with acrylics.

The next example is of *Staffa, Fingal's Cave* (1832) by J.M.W. Turner, which demonstrates his ability to show space and atmosphere. Turner, of course, used oil paints, but I feel that if acrylics had been invented in his time he would have used them too. This work can be painted in acrylics almost as if it were a watercolour, but, unlike watercolour, it can be worked over in the same way as an oil painting.

Oil paintings

Figures

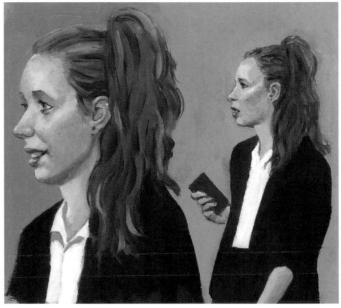

The picture **on the right** is of a girl talking to her friends. It shows a half figure and a closer portrait, making two figures in the same scene. This is an interesting thing to do, because when you have more of the figure it is not so easy to concentrate on the facial features. I painted her in a fairly natural style, showing the features as three-dimensionally as possible in the close-up, and making a contrast between the main shape

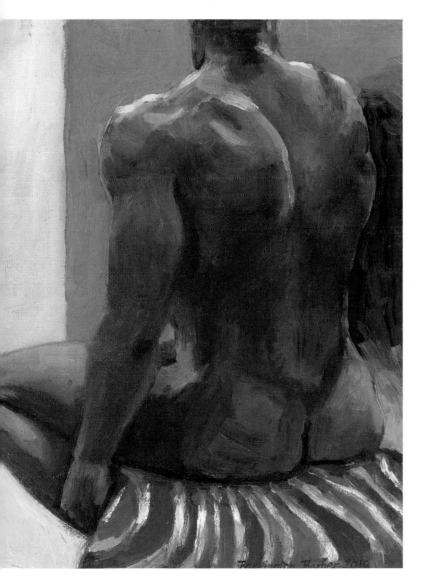

and the head in the half figure. I used oil paints, because you can do more with the quality of the colours than you can with other mediums.

Next, three different models, all viewed from the back. The painting **on the left** shows a man seated with most of his head out of the frame. This allowed me to concentrate on the muscles of his back which, as he was very athletic, could be clearly seen. The main thing was to show the bulk of the torso lit from above, with the hollow of the back in shadow. The drama of the top of the shoulders gives a very solid look to the figure. This was painted in oils from the posing model.

The subtlety of the human figure is easier to show with the richness of oil paints. The female life model **on the facing page** was better lit than the previous model. I could see every ripple of flesh and was able to translate it into paint with the subtlety of oils. Because her head was mostly hair, the form of her back became very significant. Her legs were invisible from this viewpoint, and this gave the monolithic effect of the back more potency, as with the painting of the man.

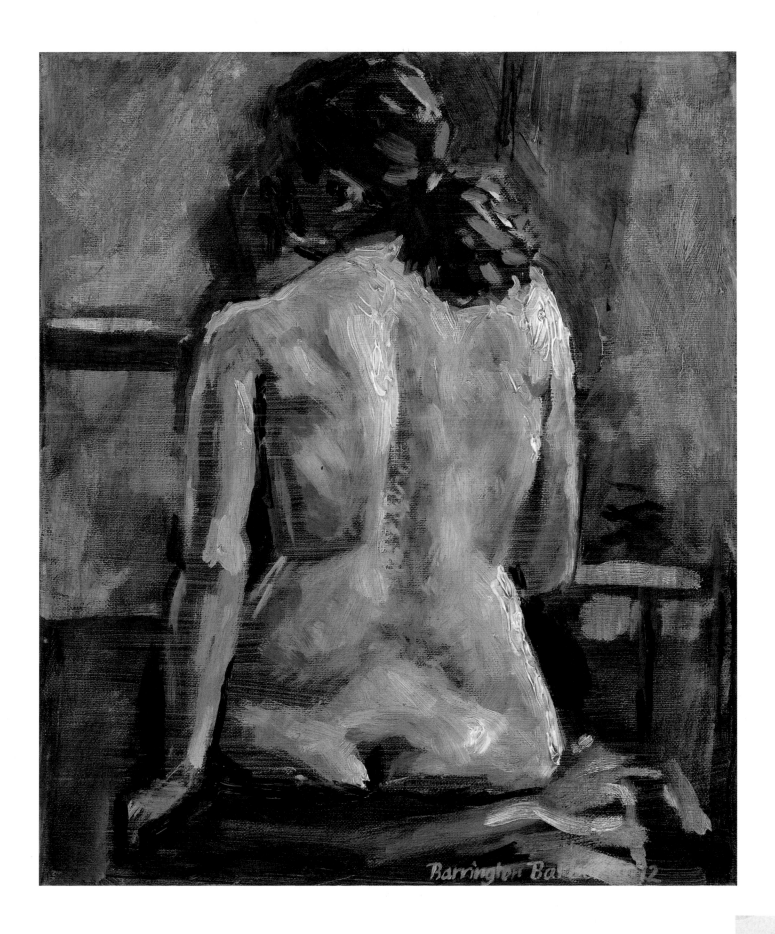

The third figure is also a woman, but she is clothed in a flowing dress with her long red hair cascading down her back. This produces a very simple but effective image, especially as the dress is blue against the strong red hair colour. It is a simple but dramatic effect for a picture.

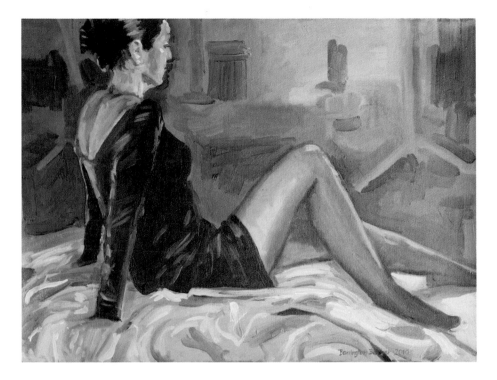

This example of a life painting, done in a costume life class, shows a professional model seated in the studio with subdued lighting. The background colours are mostly dark, and the dark dress and hair of the model echo this colour range. As you can see, the way the background has been painted in large swashes of tone is rather different from the painted marks on the model and the mattress she is sitting on. Here the brushmarks are worked in two ways, sometimes blended to produce the smoothness of the stockinged legs and elsewhere left very obvious. The contrast between the lit areas and the darker tones also plays a large part in the lively surface of the picture. This was a very quick painting, produced in one sitting, and this also lends it a certain panache.

Here are two children playing on a pavement. The weather is damp and they have both got rainwear and wellington boots on. There's a pleasing contrast between the boy's dark clothing and the girl's shiny crimson macintosh, both set against the grey of the rainy pavement, which helps to define the image. The lines of the pavement slabs are cut across vertically and horizontally by the two figures.

In this composition of three adults and a small boy amid autumn colours in a park, the boy is at the centre of the picture. The adult figures act like a bracket around his small shape. The ground is covered by yellow, brown and red leaves contrasting with the dark green background.

This very casual arrangement of figures is taken from an old photograph. As it was in black and white, giving tonal information only, I could make the colour values whatever I thought would work for the scene. I simplified the background quite a bit, as I wanted all the attention of the viewer to be on the main group of figures. All the edges of the figures are a little vague or soft so that they are not too sharply delineated against the background; it's only the tone and colour that defines them clearly.

Here I combined two photographs to make a composition where the two figures on the left are pushed slightly forward and the others on the right spread out against the remaining background. The figures stand out from the background because of their brighter or darker colours. You can see how the angles that people adopt when they don't realize that they are being observed make a natural combination of relaxed shapes that a posed picture would never have.

These paintings copied from the work of Scottish, English and French artists give you some idea of the different ways in which you can approach the human figure in a setting. The background is important because it holds the figure in a scene, which makes it more convincing to the viewer.

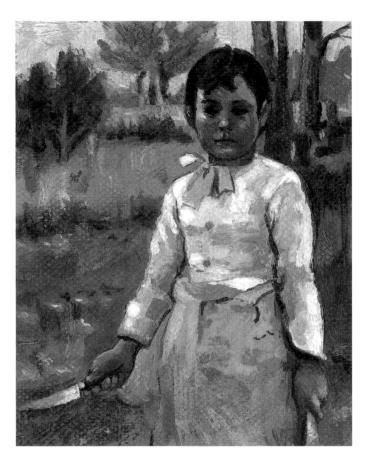

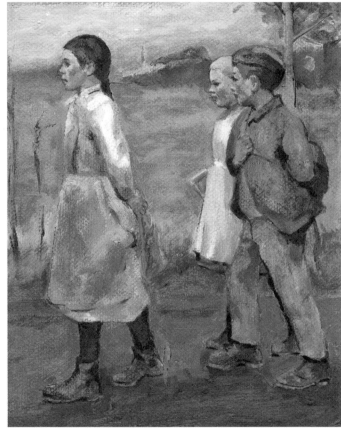

In this copy of *A Hind's Daughter* by James Guthrie (1859–1930), a young girl is cutting cabbages for her family. Guthrie has used a very muted range of colours with warm autumnal tones, apart from the brighter patches of light on the knife and the white blouse. Again the detail is reduced to show the form more solidly and the atmosphere engendered by the warm, closely linked tones gives the painting a gentle strength.

In Guthrie's painting *Schoolmates*, three young children are arranged formally against a simple countryside background. This painting is even more muted in its tonal values, with even the white clothes hardly brighter than the darks. The overall effect is that the edges of the figures are not sharp against the background and all details softly melt into the larger shapes.

In this painting, a copy of
Peasant Girl at Grez by Arthur
Melville (1858–1904), the figure
is much more sharply defined
and is brightly lit by the sun.
The branches of the vine show
clearly against the white wall of
the cottage and the pale colours
of the girl's costume look almost
faded in the light. The paint
is handled in strong, definite
marks on the canvas, which
gives the form strength and
graphic distinction and also an
effect of immediacy. Melville has
made the pattern of the shapes
caught in the contrasting light
very clear-cut, with the face of
the girl almost hidden in the
deep shadow of her scarf.

Landscape

Now let's look at the great outdoors, which is an attractive subject for painting. The examples here are some copies of great masters followed by two of my own paintings. I don't claim parity with these masters, but showing some of my own work against theirs will hopefully encourage you to see that you mustn't be daunted by them.

This example is from the great British master of the genre, Joseph Mallord William Turner (1775–1851). It is a copy of his *Norham Castle, Sunrise,* which has a marvellous quality of appearing to melt all the scene into a great abstract bath of light and colour, where everything is glimpsed but not seen sharply. The effect of light bouncing off the watery meadows and lake and the mist-enshrouded castle making a ghostly shape looming up in the background give a splendid evocation of space and open air. This was a painter who influenced the French Impressionist school of painters, and you can see how amazingly fresh and new this method of painting must have appeared at the time.

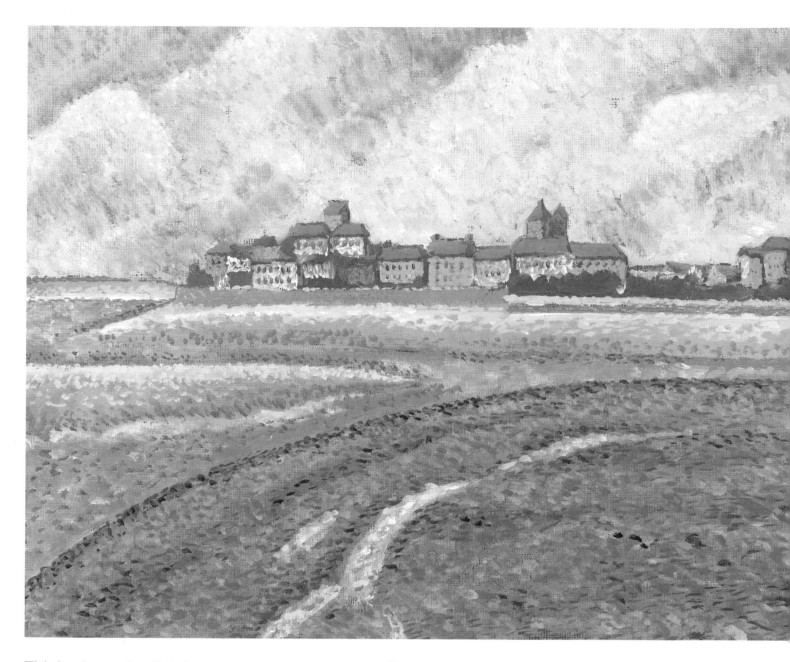

This landscape in oils is based on *View of Le Crotoy from Upstream* (1889) by Georges Seurat, a French Post-Impressionist painter who invented the technique of pointillism. I have made a close copy of it to show the way he used dots of paint to build up a picture that seems to radiate the right colour values when seen from a slight distance.

Close up, you can see the dabs of paint, often with several complementary colours alongside one another, which rely on the viewer's eye doing the mixing to see the intended colour. Seurat took pointillism to great lengths in his work; while you might not want to be so rigorous, you can see that it is an interesting effect to try.

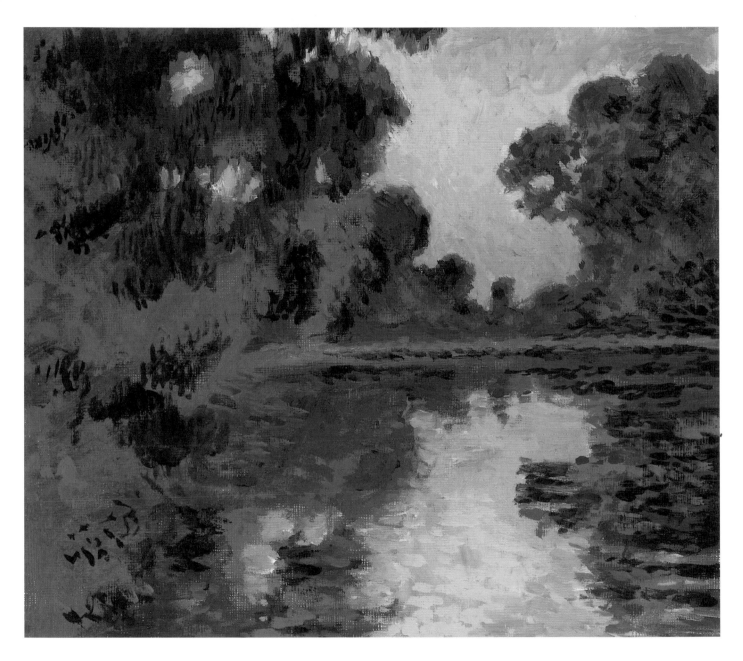

Claude Monet used techniques that were similar to Seurat's in some ways, but he applied them less scientifically. His brushmarks are looser and less didactic, and he trusted his sense of colour to give the effect he wanted. This loose copy I have done of his painting *Arm of the Seine near Giverny at Sunrise* (1897) gives a good idea of his technique, which you might want to explore for yourself. It builds up the colour in a very soft way that seems to glow out of the canvas.

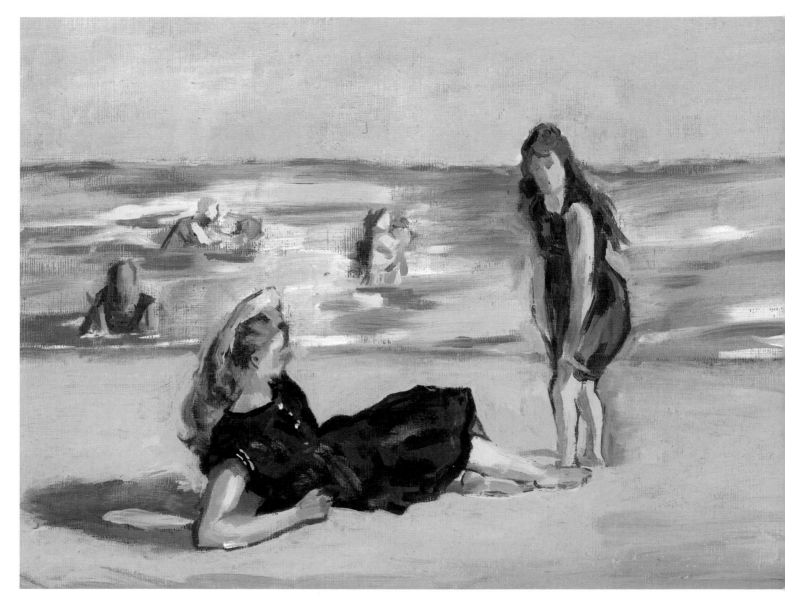

This copy of the loose, flowing painting *On the Beach* (1868) by Edouard Manet, the father of Impressionism, shows how you can achieve a very substantial painting without going into great detail. Manet's understanding of just how little you can put in a painting, while still conveying the subject to the viewer, is quite masterful. Don't confuse this with sloppy drawing – although he did not feel the need to describe every little detail, Manet made sure you could see exactly what he was portraying with great subtlety. The result is a very fresh kind of painting, which looks easier than it is. If you want to try this kind of painting I would advise copying one of Manet's works first to get to grips with his technique.

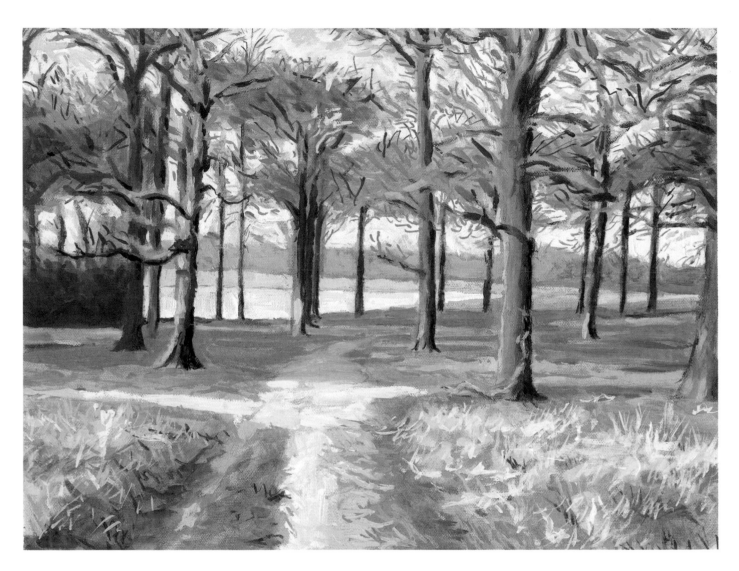

This painting is one of my own, derived from a photograph that I took in Richmond Park on the outskirts of London. The good thing about using a photograph for practising landscape is that it gives you all the tonal values you need to get the feel of the scene. I've drawn in the main shapes of the trees and landscape with solid strokes of paint, without showing any detail. The shadows on the tree trunks and branches are a mixture of very dark and lighter tonal marks, fairly loosely painted. The blocks of the sky colour showing through and behind the trees are put in to show up the pattern of the branches without being too precise as to each branch.

What is important here is the texture and density of the marks to give an effect of light and shade and to provide depth to the picture. There's no exact detail of any leaves or grass – just marks that give the effect of tree branches and vegetation. The colour values here are very carefully considered, but put on with speed and energy.

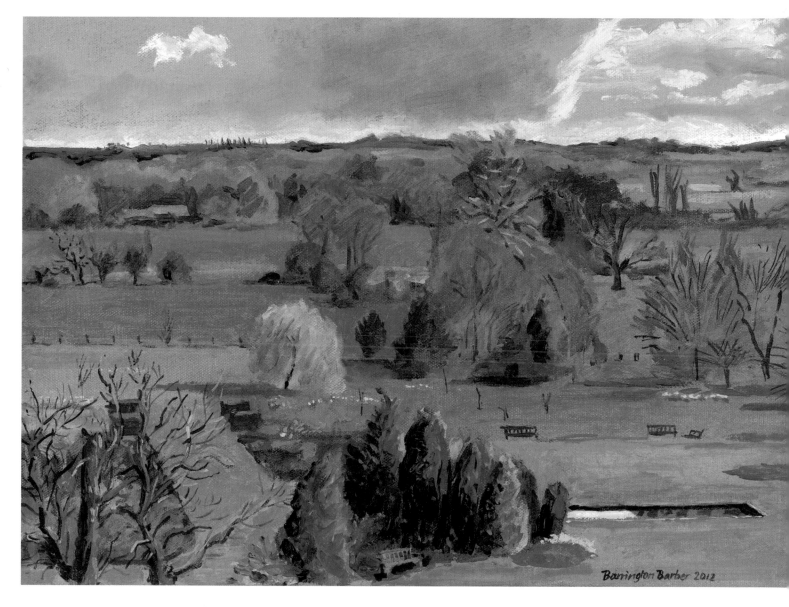

The picture here is of a garden landscape viewed from the top of a house, so there is quite a panorama to be seen. This is always a challenge, because you have to decide how much of your view you will actually paint. In the immediate foreground you can see a short stretch of water next to a clump of decorative trees and bushes, with some garden benches set further back.

Beyond are some larger trees and fields going off into the distance until there are only masses of trees on the horizon. The cloud system was quite interesting at the time I painted this and the sky takes up the top quarter of the picture. I felt that oil was the best medium for this painting because it is so good for creating subtle differences in space and colour.

Abstraction

Abstraction is popular in modern art. Here are a couple of my own abstract works to give you an idea of how you might approach the genre. I did these examples in oils, using board as a surface so that I could sandpaper some of the layers of paint away to produce interesting textures.

In the first one I layered several colours, sometimes covering the whole area, then I rubbed the painting back when it was dry to reveal the different layers of paint. This gave a less obvious effect to the colour of the main area; it also allowed me to paint over the top of it freely in various contrasting colours with simple brushmarks that filled out the space.